IMAGES
of America

FORT LEE

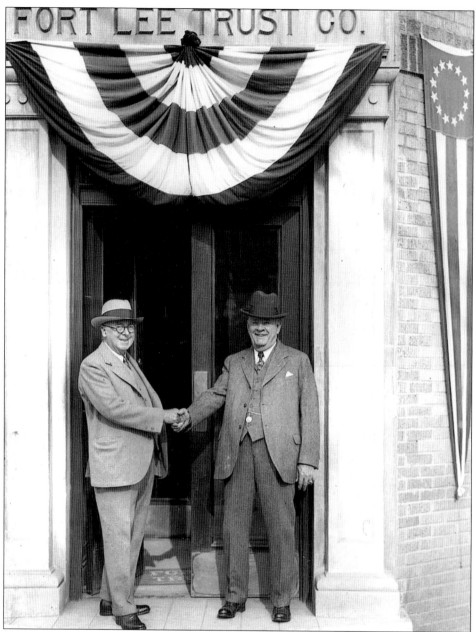

The Fort Lee Trust Company was opened at Main Street and Lemoine Avenue in December 1922. The two men pictured are J. Fletcher Creamer Sr. (left) and Samuel Corker. Creamer was one of Fort Lee's leading businessmen. He began his trucking business with one truck during the 1920s. When the George Washington Bridge was constructed, new opportunities in hauling allowed him to expand the business. His son and grandsons continue with his diversified company, which has grown into one of the largest construction firms in the United States. Samuel Corker came from an old Fort Lee family. His father emigrated from St. Helena Island, a British colony in the South Atlantic Ocean, and arrived in Fort Lee before the 1860s. Corker was a leading politician in Fort Lee. His son William served as borough clerk for decades and was also editor of the *Fort Lee Sentinel* and the *Hackensack Republican*.

IMAGES
of America

FORT LEE

Lucille Bertram
for the Fort Lee Historical Society

ARCADIA

Copyright © 2004 by Lucille Bertram and the Fort Lee Historical Society
ISBN 0-7385-3509-5

First published 2004

Published by Arcadia Publishing,
an imprint of Tempus Publishing Inc.
Portsmouth NH, Charleston SC, Chicago,
San Francisco

Printed in Great Britain

Library of Congress Catalog Card Number: 2003115285

For all general information, contact Arcadia Publishing:
Telephone 843-853-2070
Fax 843-853-0044
E-mail sales@arcadiapublishing.com
For customer service and orders:
Toll-free 1-888-313-2665

Visit us on the Internet at www.arcadiapublishing.com

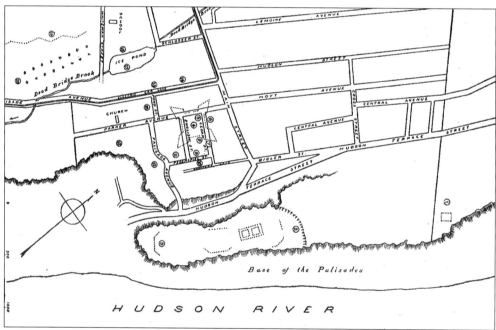

This landmark map identifies Fort Lee's Revolutionary War sites. The bluffs overlooking the Hudson River held the gun emplacements. Farther west, between Cedar and English Streets (on the north and south) and Parker Avenue and Federspiel Street (on the east and west), was the earthwork fort that held the stores and ammunition for the troops. Over the years, local citizens unearthed remnants of the fort and artifacts from the Revolution.

CONTENTS

ACKNOWLEDGMENTS

For more than 25 years, Bob Boylan, president of the Fort Lee Historical Society, has assembled and, with his wife, Mary, archived countless photographs, postcards, brochures, pamphlets, books, maps, and artifacts relating to Fort Lee history. This accumulation of over 80 boxes of material was the basis of the Fort Lee Historical Society's collection. This book would not be possible without the Boylans' diligent efforts.

Special thanks also go to the multitude of residents who made available for this book photographs from their personal collections. We must thank Fort Lee Public Library director Rita Altomara for her generosity in making available material from the library's collection.

This book would not have been possible without the expertise and untiring efforts of Margaret Hart, the editor, and Joanne Nebus, who prepared the layout.

We must also acknowledge the usefulness of the dissertation by the late D. Bennett Mazur, *People, politics and planning: the comparative study of three suburban communities*, for information it provided on Fort Lee's history and development.

Many, many thanks go to all the members of the Fort Lee Historical Society for information provided, help when needed, and encouragement.

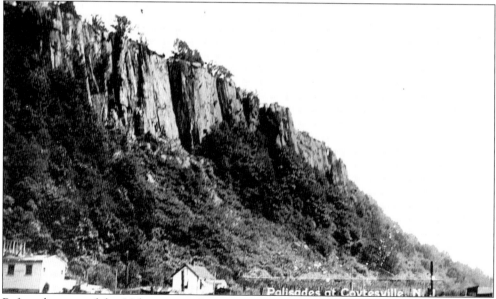

Before the start of the 20th century, firms quarrying stone along the Hudson were destroying the Palisades. The Carpenter Brothers were responsible for destroying two major landmarks. In 1893, with one blast, the site known as Washington's Head was blown away—an estimated one million tons of stone and 300 feet of the Palisades. Indian Head, the other landmark destroyed by the Carpenter Brothers, suffered even greater devastation.

INTRODUCTION

The Fort Lee Historical Society is proud to present the first published history of Fort Lee, New Jersey. Fort Lee is located at the western terminus of the George Washington Bridge. The existence of the town and its name owe much to Gen. George Washington. He established a fort here in July 1776, soon after the signing of the Declaration of Independence.

"Fort Lee's history has been tied to the cliffs on which it stands and to the River at its feet. At Fort Lee, the Hudson narrows slightly and the cliffs are closest to the river's edge." So wrote D. Bennett Mazur in his thesis on Fort Lee's history and development. The statement holds true today. Fort Lee's high-rise apartments line the Palisades for the breathtaking views of the Hudson River, the George Washington Bridge, and the city across the way. Fort Lee's location has been its boon, and at times its bane.

While this book's coverage ends with Fort Lee's 50th anniversary in 1954, there are strong hints of what was to come in the development of Fort Lee over the next 50 years. In 2004, Fort Lee celebrates its 100th year of incorporation.

Research for this history began several years ago. Local and county histories, both published and unpublished, were researched. Oral histories and reminiscences of longtime residents helped build this history. Old newspapers also provided vital information on Fort Lee's rich history.

Chapter 1 follows Fort Lee from Revolutionary times through its growth during the 19th century. Chapter 2 describes Fort Lee's political and social growth. It focuses on the vital services—police and fire—as well as the look of the community in its early years. Chapter 3 covers the institutions that have made Fort Lee famous throughout the world: the movie industry, Palisades Amusement Park, and the George Washington Bridge. Chapter 4 provides insight into two of Fort Lee's interesting neighborhoods: Coytesville and Palisade.

The Fort Lee Historical Society's purpose in producing this book has been to provide a better understanding of Fort Lee's history and development, as well as an incentive for the preservation of Fort Lee's remaining historic sites.

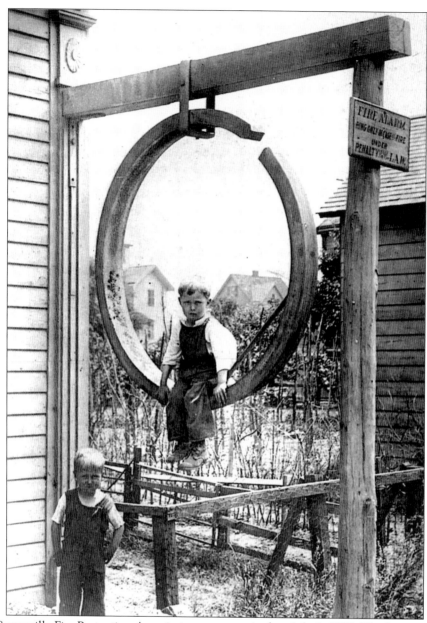

The Coytesville Fire Protection Association was organized on July 9, 1900. The first trustees of the company were John H. Mallon, William E. Wood, and John Schuster. The Board of Fire Wardens consisted of George Ranges, William Koehler, Stephen Kelly, W. F. McKenna, and Fred Hummel. The firehouse was located in Mrs. Dempsey's blacksmith shed. The Coytesville volunteers, with the aid of Maurice Barrymore, his brother-in-law John Drew, and other actors, staged benefits at Buckheister's Hotel to raise money for their own firehouse. Maurice's son, John, made his stage debut at one of these fund-raisers. The company eventually built its firehouse on Washington Avenue. The Coytesville fire ring stood outside the firehouse when it was located on Washington Avenue. On Saturday, December 18, 1926, the old fire ring was replaced by a siren that wailed so loud that residents believed it could be heard in Albany. The firehouse is now located on Lemoine Avenue.

One

EARLY FORT LEE

Soon after the American Revolution began in July 1776, George Washington moved men and equipment to a bluff on the Palisades above the Hudson River. The purpose of this encampment was to support Fort Washington across the river in New York and to prevent the British from sailing up the river. Neither purpose succeeded. Fort Washington surrendered to the British in November 1776. The Americans left Fort Lee and retreated across New Jersey with the British in pursuit. The retreat ended in a stunning rout of the British by an American force that was close to defeat.

Little development took place in Fort Lee during the first half of the 19th century. By the 1840s, there were few residents in the hamlet, most of them situated on or near the Hackensack–Fort Lee Turnpike, now Main Street.

By the 1860s and through the end of the 19th century, Fort Lee and the adjoining hamlet of Coytesville began to attract day-trippers, vacationers, and summer residents. Summer homes were built, many by the wealthy and some by the eccentric. Hotels also sprang up. By 1871, Dr. Thomas Dunn English reported that Fort Lee boasted 400 dwellings in areas known as Coytesville, Taylorsville, Irishtown (near the Bridge Plaza), and Pond Park (Parker Avenue).

When the trolleys came to Fort Lee in the 1890s, the town began to grow significantly.

Today, the oldest structures in Fort Lee are its churches. Madonna Church, Church of the Good Shepherd, Bethany Methodist, and the First Reformed Church in Coytesville all trace their origins back to the 19th century.

In 1904, Fort Lee and Coytesville broke away from Ridgefield Township to become the borough of Fort Lee. Palisade joined the borough in 1909.

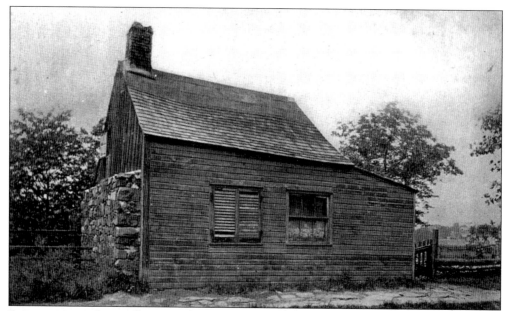

For many years, this small one-room house, located near Anderson Avenue, was believed to be George Washington's headquarters when the rebel army was stationed in Fort Lee. It was constructed of rubble without mortar. Sarah Junghans, who died in 1940 at age 90, lived there for 80 years. The building, which might have been extant during the Revolutionary period, was demolished in the 1940s.

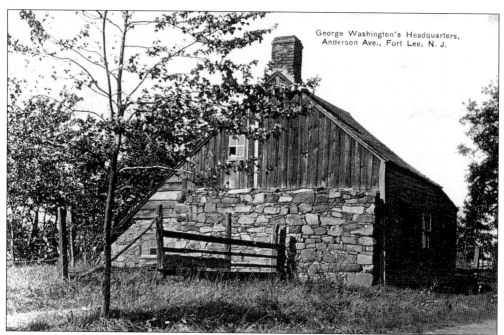

Ann Mead Fraunholz, who was an amateur historian of Fort Lee in the 1950s, credits Charles Lebright, a local government official and newspaperman, with disseminating the story of the small house being George Washington's headquarters. It is more likely that Washington stayed with Gen. Nathanael Greene in his headquarters.

Ruins of this Revolutionary War stove were photographed *c.* 1900. American soldiers set up camp in the area surrounding Monument Park. They built huts, and used stone from the area for stoves. Artifacts from the war continue to be found in Fort Lee. In the early 1970s, construction of a high-rise on Old Palisade Road obliterated the last of the ovens.

Thousands of American and British troops passed through Fort Lee in 1776. The Americans built shelters for themselves, the remnants of which could be seen into the 19th century. This photograph of the remains of a hut was taken *c.* 1900.

Parker's Pond was the water supply for the American troops stationed in Fort Lee in 1776. This is now the site of Fort Lee's Revolutionary War Monument, erected in 1908. The earthen fort built to hold stores and ammunition was located northeast of the pond—the area now bounded by English Street, Cedar Street, Parker Avenue, and Federspiel Street.

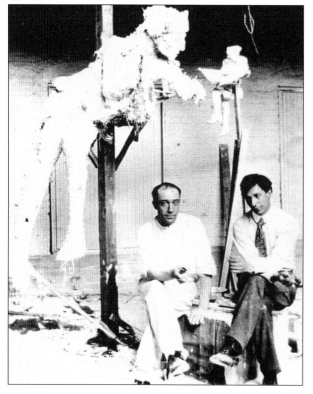

As early as 1902, a committee of local residents decided to erect a monument to commemorate Fort Lee's Revolutionary War heritage. They determined to erect it near the site of the original fort. In 1906, the design committee consisting of Peter Saitta, Leon Van Sykle, Daniel McAvoy, Adeline Sterling, and Gerome Sardi commissioned Charles Tefft (left), a well-known sculptor, to do the work for $6,000.

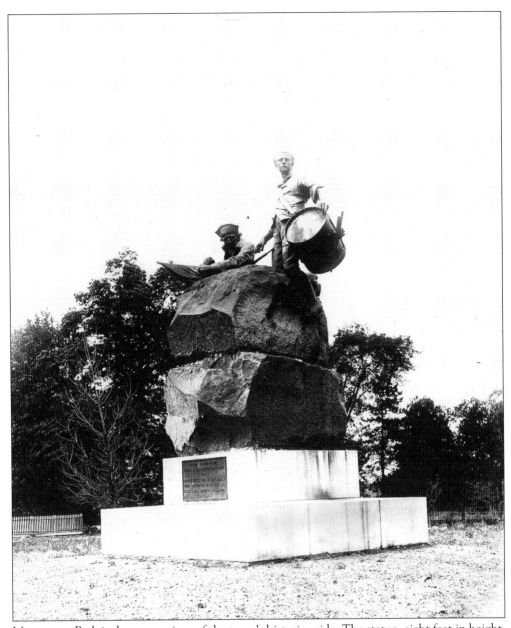

Monument Park is the centerpiece of the town's historic pride. The statue, eight feet in height, consists of a large granite base topped with a huge bluestone boulder representing the Palisades. Two bronze figures represent the American troops who were in Fort Lee: a drummer boy and a soldier scaling the Palisades.

The *New York Times* reported 20,000 people lined the streets of Fort Lee on September 26, 1908, for the parade and dedication ceremonies. The parade of civic organizations, firemen, schoolchildren, and members of the army and marines marched from Leonia Heights to Monument Park. Grace Burdette, a descendant of one of Fort Lee's first families, pulled the ribbon that revealed the statue to the cheering crowd. Gov. John Franklin Fort and Mayor John Abbott made speeches. The battleship *New Hampshire*, on the Hudson River, fired off salvos to salute the event.

Schlosser's Hotel, originally known as the Fort Lee Club House, was established in 1869 at the corner of Lemoine Avenue and Main Street. In the 1880s and 1890s, it was the origination point for many New York running clubs. Fort Lee's mayor and council met there until the 1920s. The building was razed in the 1920s, when Lemoine Avenue was extended southward. It was replaced by the Gilvan Building, which still stands.

Fisher Mansion, built in the 19th century, was located on what is now the property of Madonna Church between Hoym and Whiteman Streets. This photograph is from 1889. The Reverend Justin W. Corcoran, pastor of Madonna Church, bought three acres of the property in 1928. It was not until the early 1950s that the present chapel and school were built on the property.

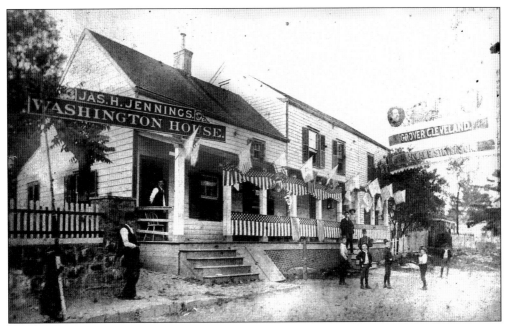

In 1892, when Grover Cleveland was seeking the presidency for a second term with Adlai Stevenson as his running mate, Fort Lee was still rural. Yet the area attracted thousands of Sunday excursionists, hikers, bicyclists, and runners. Fort Lee also had some problems. Gambling laws were often flouted. The Law and Order League, pseudo-vigilantes, ran afoul of the law themselves in their efforts to suppress Sunday drinking and gambling.

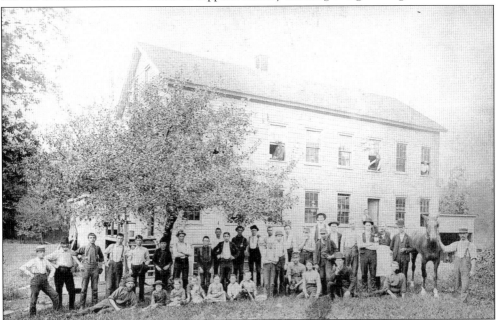

The Abbott Piano Factory was located on the west side of Lemoine near what is now the Bridge Plaza. James Abbott, an English immigrant, founded this piano-action company c. 1870. In 1912, he employed 50 men and 25 women and was a major employer in Fort Lee. The Abbott family, one of the early Fort Lee settlers, resided on Lemoine Avenue for nearly a century.

On March 29, 1904, Fort Lee officially broke from Ridgefield Township and formed its own government. In May of that year, the citizens of the borough elected their first borough council: Mayor John C. Abbott and Councilmen Peter Cella, William E. Wood, John Reardon, Charles E. Goebel, John H. Mallon, and Ferdinand Knorzer. Meetings were held at Schlosser's Hotel on the second Tuesday of each month. Their priorities were to appoint local officials, such as a borough clerk (John H. Mannix), counsel to the borough (Cornelius Doremus), and marshals to keep the peace. Among those pictured in this *c.* 1905 photograph are Charles Lebright, John Race (founder of the *Fort Lee Sentinel*), Councilman George F. Hill (later mayor), Gerome Sardi, George Heus Sr., Tax Collector Charles Bender, Arthur Kerwien (later mayor), Samuel Corker, Judge John Mannix, Dr. Max Weyler, Peter Cella, and Mayor John C. Abbott.

Seen enjoying a beer on the Hayek lawn in 1889 are Gus Fischer, Fred Fischer, Albert Langholz, John Suppus, Lewis Hayek, and Frank Hayek Jr. The table was probably crafted in the family's furniture factory. Gus Fischer and Albert Langholz married daughters of Frank Hayek Sr., and Fischer-Hayek descendants lived in Fort Lee for many decades.

Francis Hayek, born in Poland, came to Fort Lee with his wife, Joanna, in the 1860s. They bought property where Madonna Chapel now stands. Hayek was a furniture maker. Hayek's children included Francis, Mary, Louisa, Julia, Louis, Adolph, and Johanna.

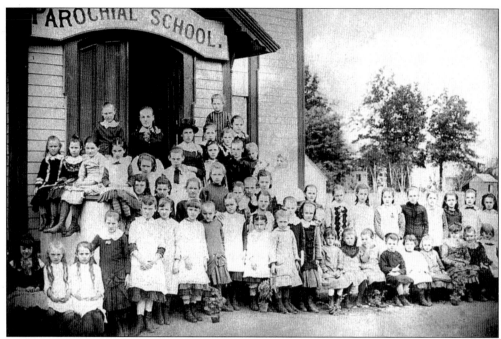

Schoolchildren of Madonna School pose *c*. 1881 at the school's original location, near where Bridge Plaza is now. The area behind the school was known as Irishtown, according to Sister Capitolina, S.S.N.D, who taught in the school in the 1880s. Some of the students at the time were Alice Corker, Elizabeth Burgard, and Bernadine Collins, as well as members of the Brosnahan, Jennings, and McNally families.

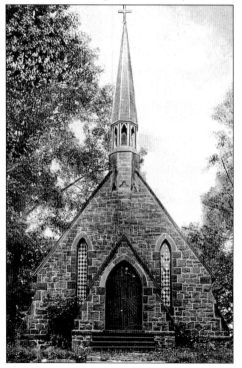

In 1885, an Episcopal congregation moved into an abandoned church known as "the Estate," on Parker Avenue. The building was later purchased for $2,000. The church became known as the Church of the Good Shepherd. The Gothic Revival building has been extensively renovated, with its entrance now on Palisade Avenue. A tower has also been added. The church is listed in *The Bergen County Historic Sites Survey 1980–1981*.

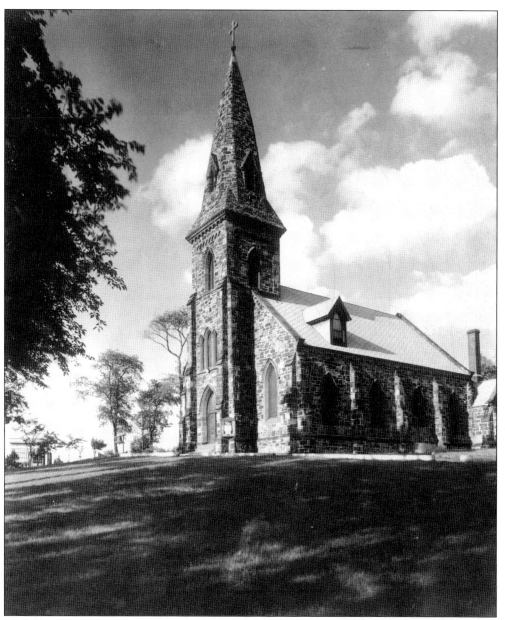

Madonna Church and Cemetery are located on Hoefley's Lane off Main Street. They stand on a hill overlooking the valley to the west. When built in 1859, the church was the tallest structure in Bergen County. Architect Jeremiah E. Burke designed it in the early–Gothic Revival style, using local bluestone. Similar materials were used to build the Church of the Good Shepherd. Jacob Riley donated and built the bell tower of the church in the 1830s. Henry James Anderson, another benefactor of the church, and his wife and son are buried in a vault beneath the church. Madonna Church is listed on the National Register of Historic Places. The Madonna Cemetery is adjacent to the church. It is the oldest Catholic cemetery in Bergen County, covering $18^1/_2$ acres. It is partly in Leonia. In 1973, a mausoleum was added to the cemetery grounds. During Veterans Day ceremonies in 2003, special homage was paid at the grave site of James Conway, a 20-year-old Fort Lee resident killed at the battle of Antietam on September 17, 1862.

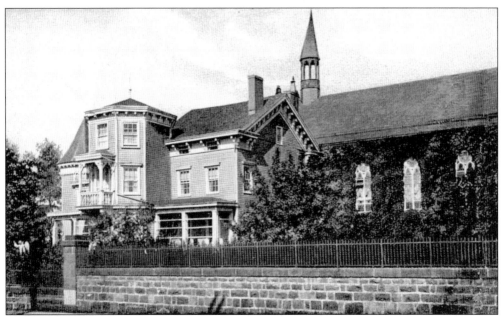

The Anderson family home was situated at the corner of Main Street and Linwood Avenue. Henry James Anderson, a physician and professor of mathematics and astronomy at Columbia College, was a major benefactor of Madonna Church. He died in 1875 in Lahore, India. After his son Edward died in 1879, the Anderson property was sold to the School Sisters of Notre Dame, who established a private girls' boarding school.

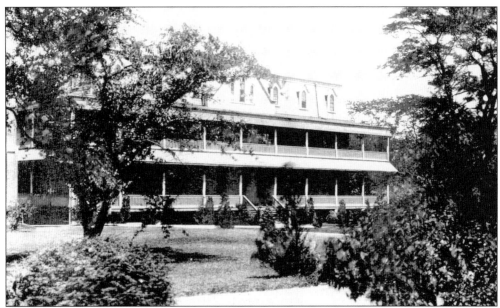

The Academy of the Holy Angels was established in 1879. Sister Nonna, the foundress, purchased the home and property of Dr. James Anderson for $10,500. Over the years, the school expanded, adding a magnificent chapel, a convent, and a five-story red-brick school with a stately dome. In the mid-1960s, the property was sold, the buildings demolished, and a high-rise apartment complex erected.

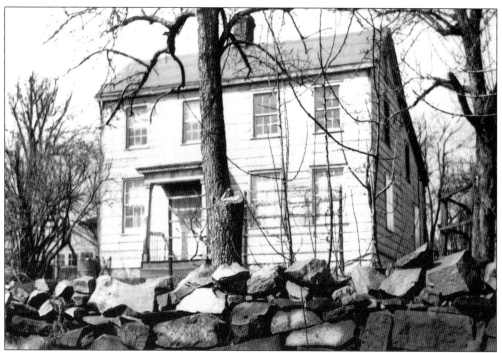

As early as 1848, Mary and Joseph Federspiel purchased land in Fort Lee. In 1857, they bought a piece of property from Benjamin Parker that was only six feet wide. The property gave the family access to Old Palisade Road, and the family created the road that bears their name. Mary Federspiel, it is recorded in Fort Lee chronicles, found Revolutionary War artifacts on her property.

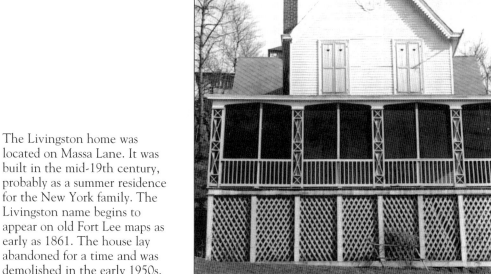

The Livingston home was located on Massa Lane. It was built in the mid-19th century, probably as a summer residence for the New York family. The Livingston name begins to appear on old Fort Lee maps as early as 1861. The house lay abandoned for a time and was demolished in the early 1950s.

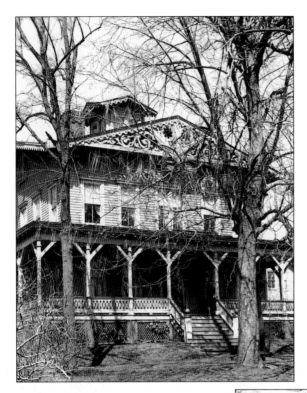

This house on Guntzer Street and Center Avenue is early Victorian. It had 17 rooms. Built in the 1860s or 1870s, it served as a summer home to John W. Guntzer, a New York alderman and tavern owner. The Engl-Szabo family—two sisters and their husbands, their mother, and their children—purchased it c. 1900. It was demolished in the 1970s.

This home, shown in the late 1930s, was believed to have been the residence of the dancer Lola Montez. In 1858, Marie Dolores Eliza Rosanna Gilbert purchased property in Fort Lee from Benjamin Parker. Her "cottage" was located at the southern end of Parker Avenue. It is interesting to note that in the 1840s, Montez was the mistress of King Ludwig of Bavaria.

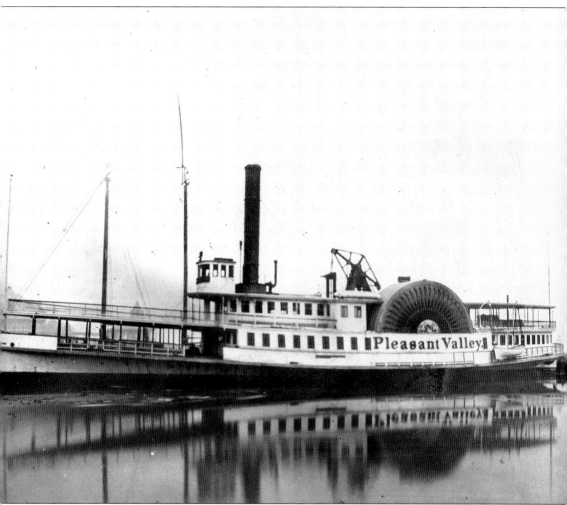

The steamboat *Pleasant Valley*, owned by the People's Ferry Company, served as an important ferry operation between New York City and Fort Lee. Launched in 1870, the ferry plied the waters from Spring Street (later starting at Canal Street) to Fort Lee with stops at Shady Side and Pleasant Valley, both now part of Edgewater. The ferry cost $60,000 to build and was 165 feet long and 26 feet wide. It was reported in an 1871 New York newspaper that on a weekend during the summer, the *Pleasant Valley* would carry as many as 2,500 passengers. In Fort Lee, beer saloons and drinking booths would greet them as they strolled thorough town. An 1873 advertisement for the *Pleasant Valley* stated that the fare was a mere 15¢, and the boats left New York four times a day, at 10:00 A.M., 2:00 P.M., 5:15 P.M., and 7:00 P.M.

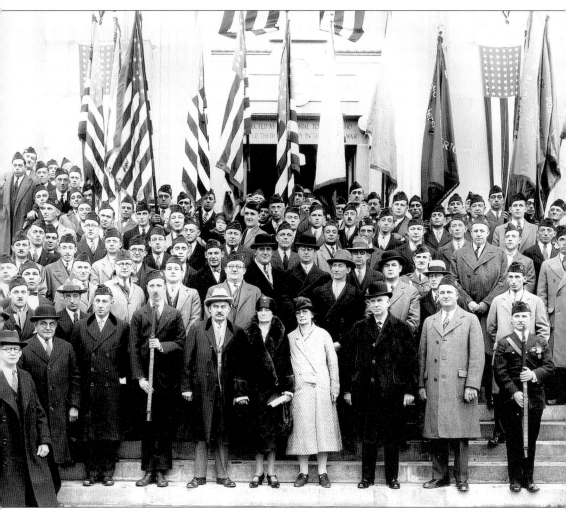

Veterans and their families pose on the steps of Fort Lee's Memorial Municipal Building at its dedication ceremony in 1929. The building was dedicated in memory of the men who died in service during World War I: Sgt. Raymond J. Cairola, Pvt. Werner Ebell, Pvt. Clinton Hallenbeck, J. M. Houlihan, Engineer John Thomas Keegan, Pvt. John T. Mahon, Cpl. Alexander G. Nurse, Pvt. Frederick Weiss, and Julius Zannetti. Raymond J. Cairola was the first from Fort Lee to die in World War I. He entered the service in May 1917, was seriously injured, and died from his wounds in May 1918. Mahon, Nurse, and Zannetti died in battle. Several of the soldiers died not from wounds received in battle but of influenza, which had reached epidemic proportions during that period. Fort Lee's Veterans of Foreign Wars (VFW) post was named in honor of Cairola.

Two
A Community Grows

Fort Lee was incorporated in 1904, becoming one of the last boroughs to break away from the old Ridgefield Township. At the time, Fort Lee had three established schools, and the fire department consisted of three all-volunteer companies. The Palisade section joined Fort Lee in 1909 and added a fourth school and fire company. It was necessary, however, for the borough council to pass an ordinance establishing a police force.

Fort Lee had an estimated population of 4,000 in 1904. The Abbott Piano Factory was the main employer. There was a small photographic manufacturing plant on Gerome Avenue and a book bindery firm in Coytesville. Many residents commuted to factory jobs in Edgewater or to white-collar employment in New York City.

Churches were well established in Fort Lee. Madonna, Good Shepherd, First Reformed and Bethany Methodist were founded in the 19th century. Fort Lee also boasted a private Catholic girls' academy, established in 1879.

Fort Lee's most drastic changes occurred between 1910 and 1931. The movie industry came and flourished for 10 years before moving west. Rumors of a Hudson River Bridge sent the borough on a building spree that resulted in some of Fort Lee's finest architecture: the Memorial Municipal Building, on Main Street, and Fort Lee High School, on Lemoine Avenue.

Local businesses began to thrive. Real estate provided opportunities for many locals in the 1920s, but the Great Depression reversed many a fortune.

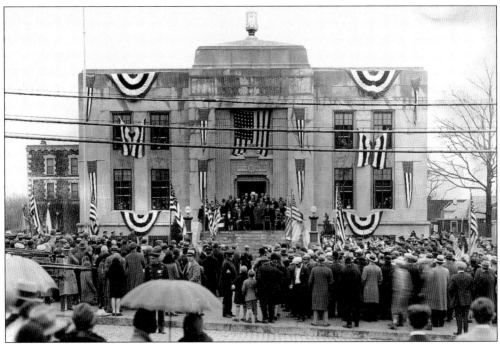

Fort Lee's Memorial Municipal Building, at 309 Main Street, was completed in 1929. The building is one of the finest examples of Art Deco style in Bergen County. Granville W. Dexter, a resident of the Palisade section, was the architect. The builder was Frank W. Bogert. The building originally housed all government offices, including the public library, the police department, and the public works department.

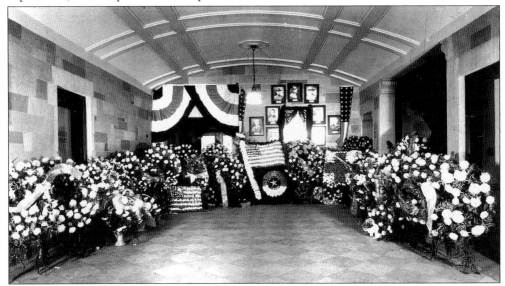

The entrance to the Memorial Municipal Building is graced with decorated bronze doors. The floors are terrazzo, and the interior walls are faux-marble plaster. A barrel-vaulted ceiling graces the beautiful interior. In this dedication photograph, the portraits of Fort Lee's fallen World War I soldiers are on the back wall. Their portraits still hang in the entrance. The building has been renovated extensively to meet the needs of the expanding community.

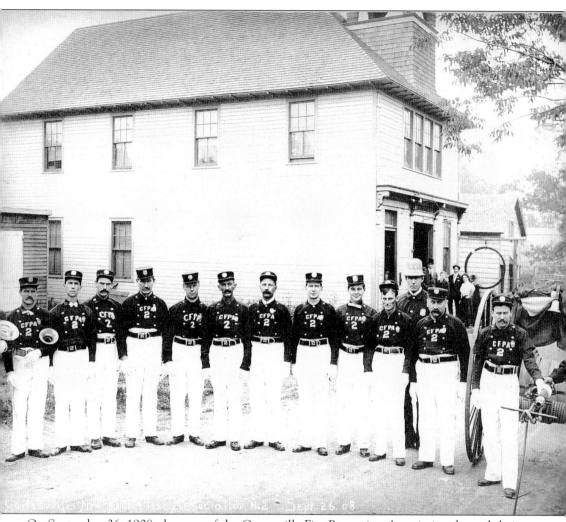

Coytesville Fire Protective Association No.2 - Sept. 26. 08

On September 26, 1908, the men of the Coytesville Fire Protection Association donned their dress uniforms and assembled in front of their firehouse on Washington Avenue for a very special occasion. Fort Lee would be dedicating the Revolutionary War Monument in the park next to the Church of the Good Shepherd. All Fort Lee fire companies would assemble for the event. The firemen were also bringing some of their equipment to the parade—a hose reel draped in bunting. The company also owned a two-ladder truck (pulled by horse or man), which carried leather buckets for emergencies when a hose could not be used. Among the early officers of this company were John Whiteaker, Joseph Walters, John Tierney, Charles Truman, Charles Lilley, John Kearny, James Carney, and Fred Bollenback. The firehouse still stands. It has been converted into a business office.

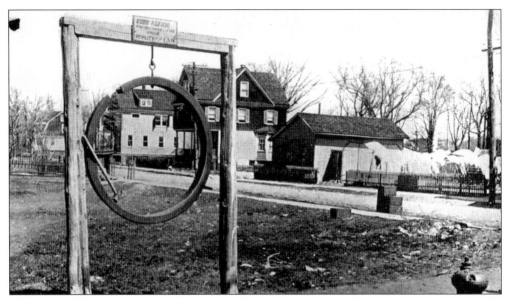

Hoyt Avenue was named for the Reverend Ralph Hoyt, an early Fort Lee clergyman who helped found the first Episcopal church in Fort Lee. The ancient fire ring pictured above was located at the corner of Hoyt Avenue and Main Street.

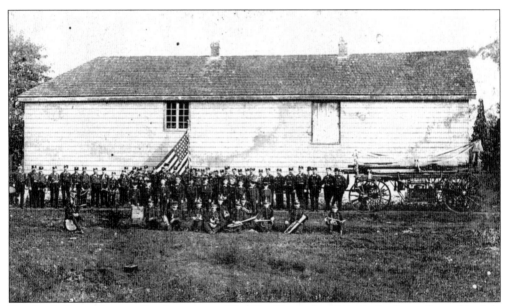

Fort Lee's first volunteer fire department (the Fire Protective Association) was formed in July 1888 at Schlosser's clubhouse. Among the first members were Morris Hanower, George Linder, Philip Beyer, John A. Brandt, Arthur Kimble, Charles A. Hundt, Edward Fitzgerald, Louis Schlupp, William S. Kalisher, John A. Lang, James McNally, Joseph Schlosser, Jacob Beyer, Guido Semmendinger, William Hyle, T. A. McNally, Andrew Roos, Gustave Schuman, L. H. Van Sykle, and Henry Bennecke.

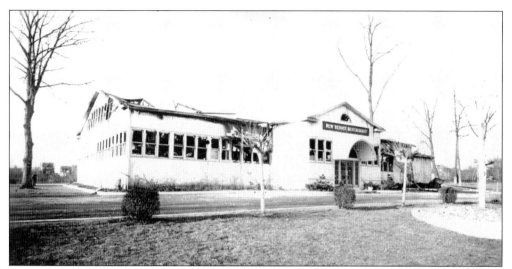

Angelo Travaini owned the New Venice Hotel, on Hudson Terrace in Coytesville. The main building was destroyed by fire in February 1930. In December 1931, three employees were killed in a second fire. In 1934, the borough issued a license for the establishment of a dog track on the property. The Fort Lee Kennel Club installed an electrical system and built a grandstand and track but was refused state approval.

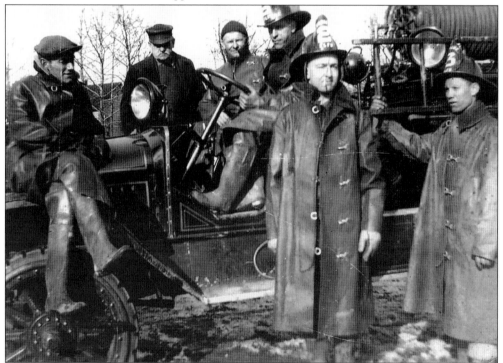

The Fort Lee Fire Department fought two blazes at the New Venice Hotel. Both fires occurred on cold, blustery nights. Lack of water pressure hampered firefighting efforts. The blaze did considerable damage to the restaurant building, which was rebuilt. Shown in the photograph are men from Fire Companies No. 2 and No. 3. Mayor Louis Hoebel also assisted in fighting the fire.

Fire Company No. 3 was founded in 1902 in West Fort Lee, known as the Taylorville section of Ridgefield Township. Two years later, after vigorous fund-raising, the company purchased land on Jones Road for a firehouse. John Frate built the foundation. John Riker, Adolph Thoms, and George Allstadt, with the help of members of the company, built the structure. The company later moved to new quarters on Main Street.

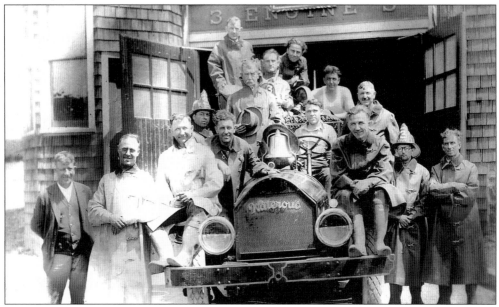

Posing in front of the firehouse in 1925 are members of Fire Company No. 3. All Fort Lee fire companies are volunteer. Much of the equipment, such as the Waterous pumper in the photograph, was bought second-hand from other fire companies. The only identified men in the photograph are Louis Hoebel (second from left) and Louis Bertram (upper left). Both men served as chief.

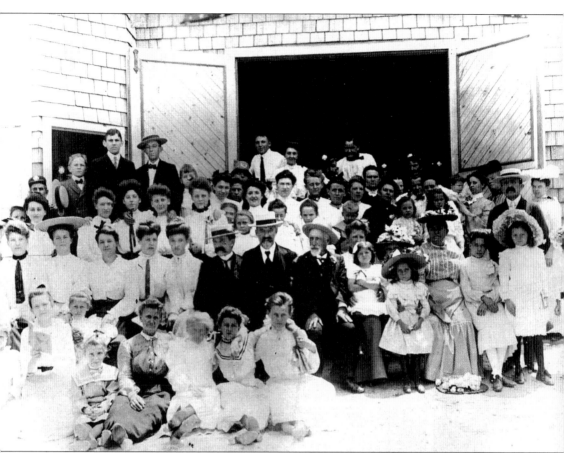

The 1904 opening of the new firehouse on Jones Road brought out almost all of Taylorville. The people shown in this photograph include May Reardon, Francis Meesig, Nellie Beyer, Lillie Beyer, Kate Meyer, May Marx, John Mannix, Mayor John Abbott, Jard Bowkite, Frieda Bock, Carrie Hook, Mrs. C. Rosenstengel, Elsie Allstadt, Elsa Bock, Clara Hook, Adie Marx, Helma Thomas, Bob Klein, Maggie Laneri, E. Mills, H. Thom, Kate Merkle, Eberhardt Meyer Sr., Tillie Rosenstengel, Frank Mills, Joe Marx, Ed Merkle, Mrs. Charles Merkle Sr., and Charles Glaser.

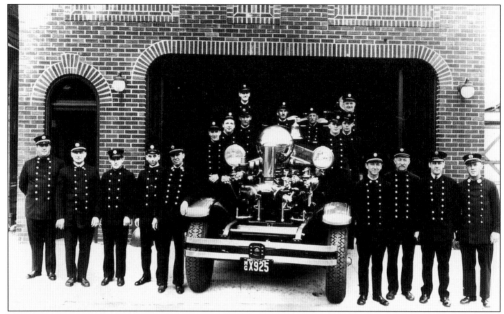

A total of 154 companies participated in the New Jersey and New York Volunteer Firemen's Parade, hosted by Fort Lee on July 19, 1932. These members of Company No. 1 are, from left to right, Anthony Gerardi, George Lautenschlager, Jules Marcus, Lester Ghent, George Kipp, James Dillon, Joseph Taus, John Tracey, Reginald Schutz, Frank O'Connell, Charles Killinger, Clarence Yeomans, Arnold Glauser, George Lardner, Edwin New, Harry Barbieri, William Connell, and Walter Williams.

Frank Schmidt Sr. and his sons Adam Schmidt and Frank Schmidt Jr. were members of Fire Company No. 2. Frank Schmidt Jr. served as chief in 1936, the year the Riviera nightclub burned. The elder Frank came to this country in 1872 and settled in Coytesville with his wife, Louise.

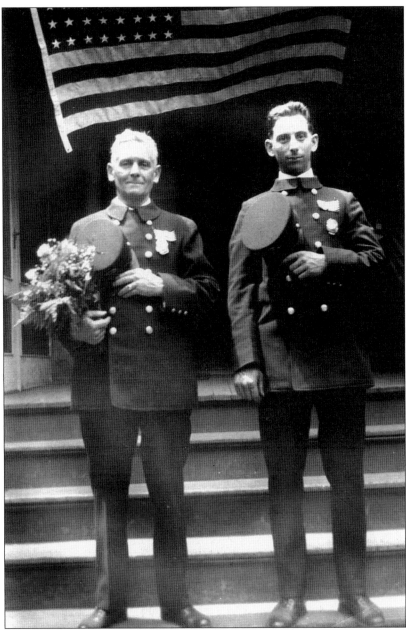

Herman and Rachel Ghent and their children, Lester, Ruth, and Sophie, lived on Hoyt Avenue. Herman was a plumber and tinsmith, establishing his business as far back as 1895. The family plumbing business on Parker Avenue was one of the longest-running businesses in the borough. Herman, his son, and grandson (Lester Ghent Jr.) all served on the Fort Lee Fire Department, and they all served the department as chief. They are the only family to accomplish this. Lester Ghent Jr. is still a member of Fire Company No. 1, accruing more than 50 years of service. Fire Company No. 1 is the proud owner of the vintage Ahrens-Fox fire engine originally purchased in 1929. It is featured at many volunteer firemen's events in the tri-state area, at borough events and parades, and at the fire department's Christmas party. The fire engine is tended lovingly by Lester Ghent Jr.

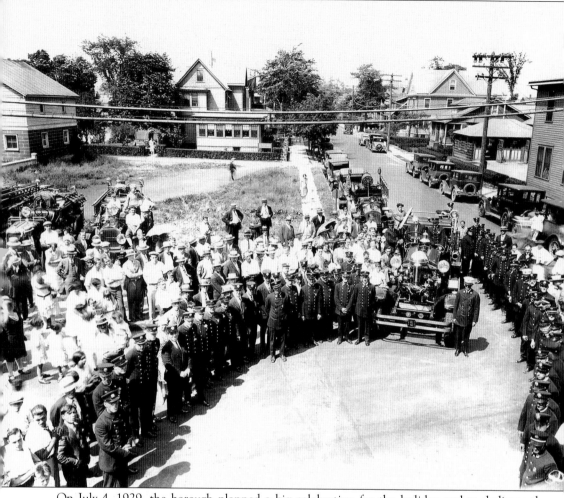

On July 4, 1929, the borough planned a big celebration for the holiday and to dedicate the newly completed brick firehouse of Fire Company No. 1. The construction cost over $8,000. The building was completed in two months, with members of the company donating their services and some materials. Members of the fire company took out personal loans to help finance the construction. A carnival was also held to raise funds. A new Ahrens-Fox fire engine was acquired for the new firehouse. The fire engine was in use for several decades. The firehouse celebrates its 75th anniversary in 2004.

In this photograph, members and dignitaries pose on Hoyt Avenue for the occasion. Lawrence Dobbelaar, over 80 years old, recounted events from the early days of the fire department. George Kipp, president of the fire company, acted as master of ceremonies. A moment of silence was observed in memory of Fred Cavaliere, the first Fort Lee fireman to die in the line of duty—a movie-studio fire in February 1925.

The members of this Fort Lee band are, from left to right, as follows: (first row) unidentified, Al Shaw, two unidentified, and Raymond Troy; (second row) Al Mohan, unidentified, ? Messig, ? Lehman, ? Rosenstengel, unidentified, Ray Hafley, ? Rosenstengel, unidentified, and Lester Reardon; (third row) Charlie Mickel, four unidentified, John Allstadt, Louis Messig, Lester Ghent, and four unidentified. Lehman and the Meesigs were all veterans of World War I.

Members of the Ladies Auxiliary of Fire Company No. 1 pose in 1932. They are, from left to right, as follows: (first row) Mrs. J. Slater, Mrs. J. Burgard, Mrs. E. Lang, Mrs. P. Ricco, Mrs. G. Heus, Mrs. G. Semmendinger, and Mrs. D. Skelley; (second row) Mrs. A. Doscher, Mrs. A. Willerhausen, Mrs. G. Shay, Mrs. O. Cassi, Mrs. J. Steinmetz, Mrs. C. Perrin, Mrs. A. Kennedy, Mrs. M. New, and Mrs. A. Gerard; (third row) Mrs. M. Healy, Mrs. S. Cavinato, Mrs. H. Hafley, Mrs. A. Nelson, Mrs. G. Diehl, Mrs. G. Kipp, and Mrs. G. Kinsler.

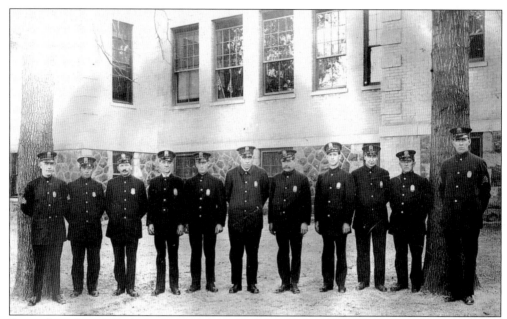

Pictured in this 1917 photograph of the Fort Lee police are, from left to right, Pat Hartnett, Charles Jockel, unidentified, Tom Dalton, two unidentified, Archie ?, Joe Rosenstengel, ? Van Kuren, ? Heft, and Andrew J. McDermott. McDermott began service on the Fort Lee Police Department in 1907, when he was appointed a marshal by Mayor Daniel W. McEvoy. McDermott was appointed police chief in 1927 by Mayor Edward White and served until 1947.

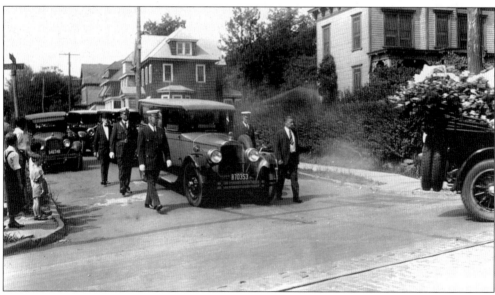

Capt. William Whipple, a member of the Palisades Interstate Park Police for 20 years, died suddenly in July 1931. He left a wife and six children. His funeral cortege is shown here as it exits Gerome Avenue. The Rupp house (right) was built c. 1870. The house, the only remaining example of domestic architecture on that section of Main Street, was demolished in 2003.

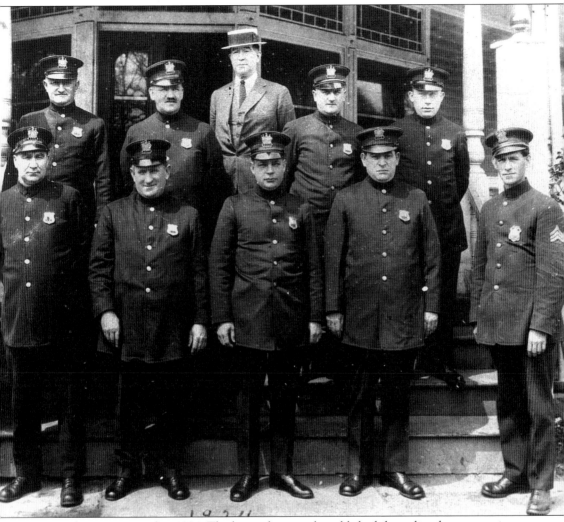

Fort Lee police are pictured in 1924. The borough council established the police department in 1904. The police committee of the council, with borough marshals, made up the department. The marshals were paid $3 for 12 hours of service. The chairman of the council's police committee acted as chief, but without compensation. Little had changed in the police department in terms of leadership. There was no full-time, paid police chief. This would continue until 1927, when an ordinance was enacted authorizing the naming of a chief and the appointment of a councilman as police commissioner.

The ordinance also provided that "no member of the Police Department shall be removed from office or employment for political reasons." To be appointed to the department under the 1927 ordinance, the applicant needed to be a resident for two years, weigh at least 150 pounds, stand at least 5 feet 8 inches, and have no conviction for any crime involving moral turpitude.

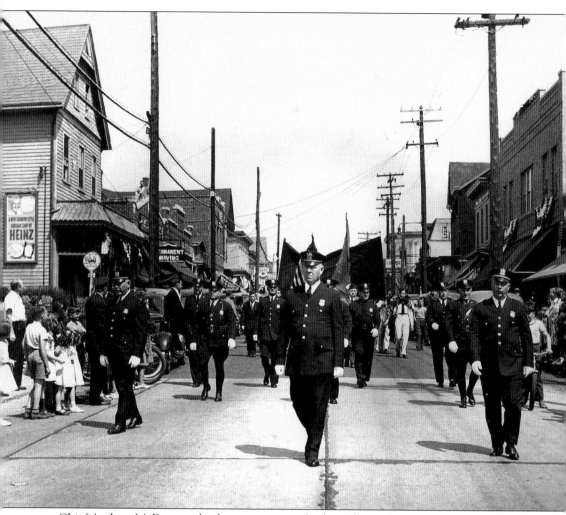

Chief Andrew McDermott leads a contingent of police officers down Main Street in the 1940s. Also marching are Charles Kurz, Theodore Grieco, John Heil, Bill Scheurer, and Arthur Bruns. Chief McDermott retired in 1947 and was replaced by Chief Fred Stengel. Carl Meyn was named chief in 1951, followed by Theodore Grieco. The Fort Lee Police Department faced immense challenges in the 1940s. The voluminous motor vehicle traffic from the George Washington Bridge and Route 4 led to innumerable accidents and fatalities. Gamblers came across the George Washington Bridge in increasing numbers as New York effected strict enforcement of its gambling laws. Rumors were rife that a number of taverns, businesses, and nightclubs in the area housed gambling dens. Places with names like "the barn" and "the studio" were often mentioned. The North American Baby Carriage Factory was probably the best known of the establishments.

The Reverend Robert J. Clarke was rector of the Episcopal Church of the Good Shepherd from 1937 to 1968. He was a cabin boy on the *Lusitania* when it was torpedoed and sunk in 1915. He served in the Royal Navy during World War I. His years in Fort Lee also provided some adventure. As fire department chaplain, during a fire at Palisades Amusement Park, he rescued several children.

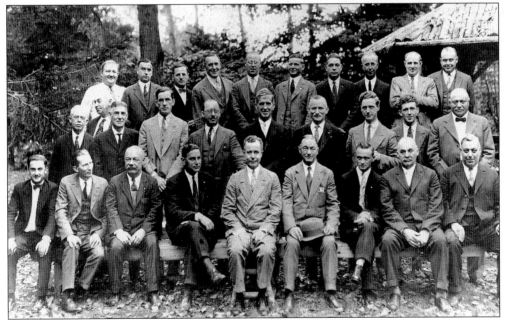

The members of Fort Lee's Rotary Club shown in this 1929 photograph are, from left to right, as follows: (first row) Louis Leone, Joe Rutter, Arthur Weisker, Dick Pagluighi, Fulton Hardman, Newt Bollan, Patty McClellan, William Ennis, and unidentified; (second row) Jim Jennings, Dick Hardy, Bill Corker, John Hart, unidentified, Peter Cella, ? Klingberg, unidentified, and Peter Diehl; (third row) George Schlosser, Joe Cook, ? Golden, Peter Grieb, Louis Hoebel, George Lahm, John Flynn, Henry Hoebel, Harry Elkart, and Ed Wood.

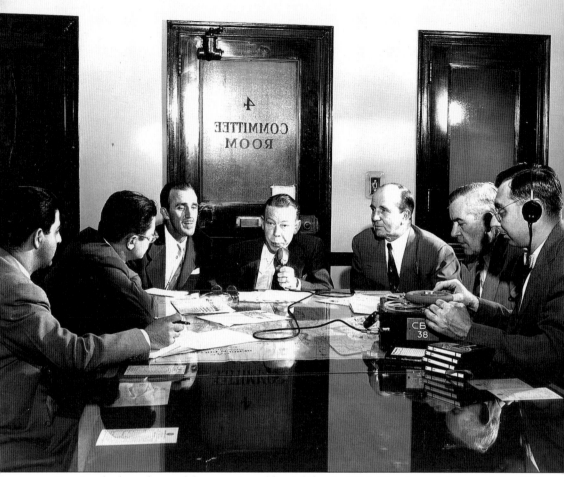

Fort Lee had much to celebrate at its golden jubilee in 1954. The financial woes of the 1930s were over, and new construction had begun. In April, the borough was putting out the word on radio that the community was strong and growing. Pictured, from left to right, are Anthony F. Mauriello, Martin Weldon (CBS commentator), William S. Hart (co-chairman of the Golden Jubilee Committee and councilman), Louis F. Botjer (mayor), John Kerwien (co-chairman of the Golden Jubilee Committee and councilman), William S. Corker (borough clerk), and Ed Lapinsky (CBS engineer). The borough hired an event planner for $4,000 to coordinate the weeklong celebration. Over 3,000 people marched in the parade to inaugurate the celebration. It was estimated that there were 7,500 viewers along the route. The week's events included a Miss Fort Lee pageant, a Pioneers Night, a soapbox derby, and Youth Day (when students took over the reins of government). The closing event was a huge open-air block dance.

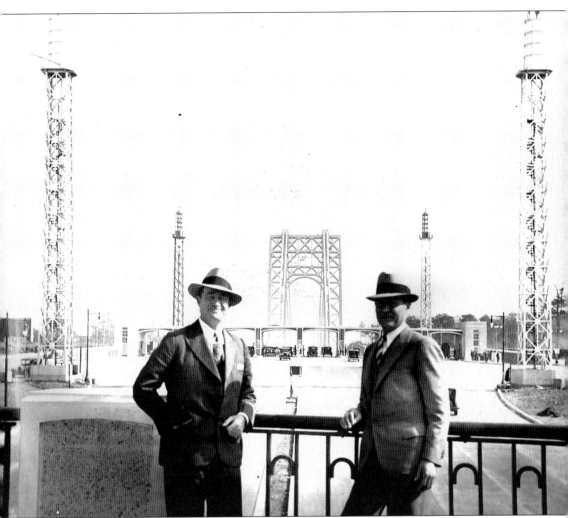

Eberhard "Abe" Meyer (left, standing at the new Bridge Plaza) was a Fort Lee councilman in the early 1930s. Meyer was a veteran of World War I and was a member of the Fort Lee Athletic Club. In 1934, as a councilman, he served as police commissioner and forced passage of a resolution granting him complete authority over the department. In a particularly acrimonious debate, in an attempt to increase his power base, he hinted at graft in the police department and malfeasance by Mayor Arthur Kerwien. His resolution was passed over the mayor's veto. By 1935, he was out of office. In an interview with the *Palisadian* in 1935, he said he had no use for the abuse that goes with office holding. After opposing the council manager form of government while in office, Meyer was in favor of it when out. Meyer operated a real-estate business in Fort Lee for many years.

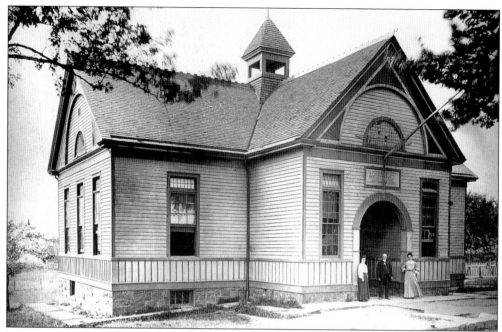

School No. 2, originally known as the Leonia Heights School and later West Fort Lee School, was built in 1895 as a two-room schoolhouse. Fort Lee was then part of Ridgefield Township. Property for the school on Jones Road was bought from William Casper. A second floor was later added. At the beginning, Lydia Bennett served as principal and sole teacher. She taught some 70 students in all levels.

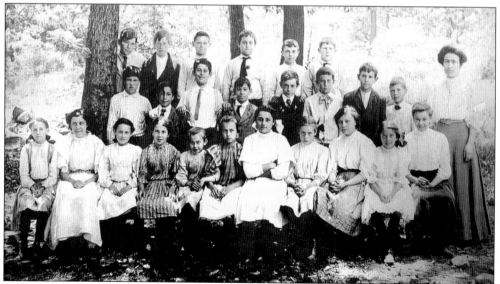

The fifth-grade class of School No. 1 poses in 1908 with teacher Eva Bratt. From left to right are the following: (first row) Prisci Johns, Sadie Meeks, Olga Buckheister, Annie Kuhnast, Clara Wadhouse, Elmyra Wadhouse, Ermanda Campanosi, Augusta Stuart, Henrietta Springs, Mildred Corker, and Annie Roland; (second row) Fred Oettel, Frank ?, Tulio Giammencheri, Oreste Cassi, Gustave Braun, John Hundeman, and Edwin Richter; (third row) Harold Marzorati, Charles Stuart, Carl Lautenschlager, and Richard Giammencheri.

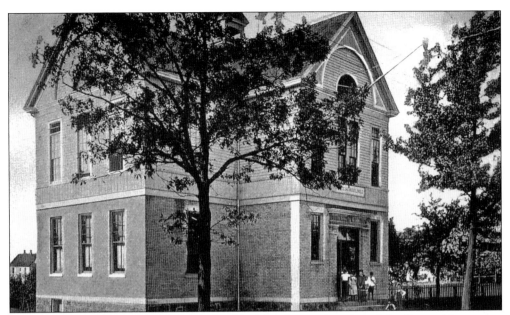

The school board received $35,000 for land lost for the construction of the Route 46 overpass. The money was desperately needed to renovate School No. 2. Fort Lee was in a financial crisis in the 1930s, and its fiscal affairs were run by the state finance committee, which refused to allow the expenditure. Over the protests of local parents, the state stepped in and closed the school for almost two years.

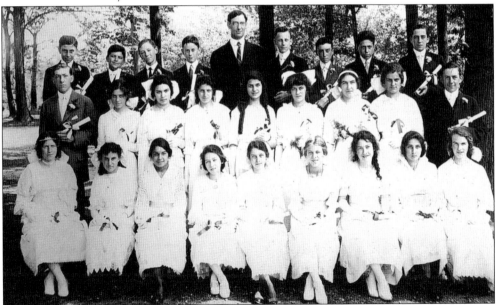

The eighth-grade graduating class of School No. 1 is pictured in 1914. Included in the photograph are Madelyne Aiken, Vincent Barry, Louis Bertram, Audrey Byrne, Elsie Ehrlich, Sadie Heft, Ethel Hill, Carl Kaiser, Lena Kaiser, Jennie Lane, Vidya Merz, James McCabe, Louis Moskowitz, Emil Muench, Marjorie Naudet, Edwin New, Laura Nicolini, Mabel O'Connell, Samuel Perlow, Ernest Richter, Susie Ruckenbrod, Rose Semmendinger, Mary Sbarbero, Elsie Schlupp, Philip Traverso, and Marie Walsh.

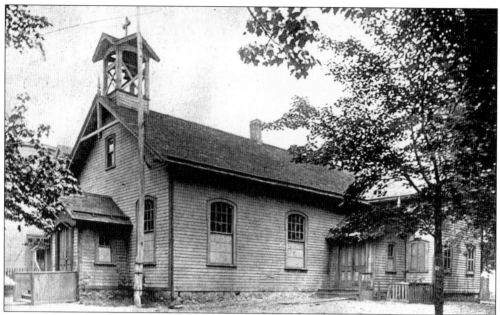

Madonna School was originally located north of the present Bridge Plaza. In 1919, it was deemed too small and was replaced by a red-brick structure on Lemoine Avenue just north of Main Street. The church sold the property in 1950. The Lee Theatre, Warneke's ice-cream parlor, and several stores replaced the school. The Lee and Warneke's were razed in the 1970s for a Helmsley project, which never developed.

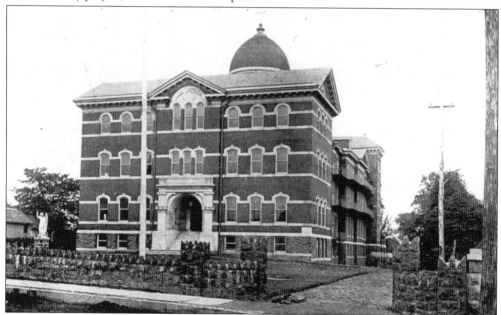

In November 1908, the cornerstone for a new $300,000 school building was laid for the Collegiate Institute of the Holy Angels. Some 2,000 people attended the ceremony. In his address, the Reverend Robert Burke stated, "Unless we educate a race of holy and virtuous maidens we will not have loyal and faithful wives and mothers, and the consequence will be imbecile and degenerate sons unfit for college education."

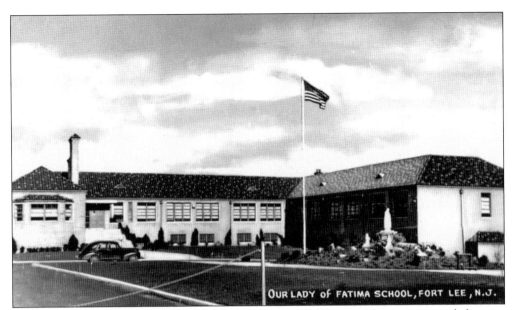

OUR LADY of FATIMA SCHOOL, FORT LEE, N.J.

In 1951, the pastor of Madonna Church, the Reverend Thomas Morrissey, named the new school on Whiteman Street in honor of Our Lady of Fatima because of his special devotion to that event in Portugal. The school was built by Romagnino Construction. The School Sisters of Notre Dame taught at the school. In the 1970s, it again became Madonna School. In recent years, it became a diocesan school called Christ the King School.

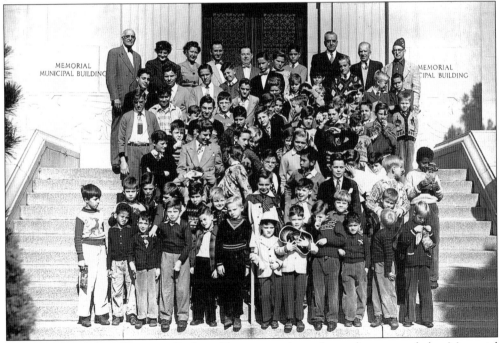

Children from the Christian Orphan Home are pictured on the steps of the Memorial Municipal Building. They are on a Lions Club–sponsored outing led by Gus Grossman (top left), owner of the Fort Lee Diner. The home, founded in 1900, moved to 1512 Palisade Avenue in 1923. The name was later changed to the Christian Home for Children.

45

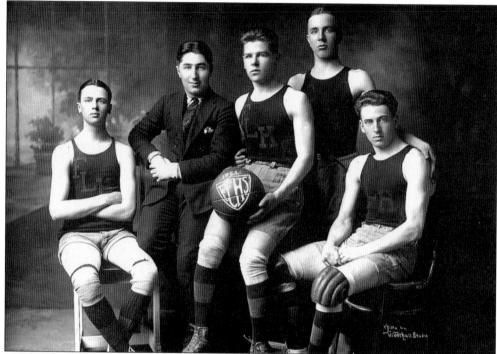

In 1921, the high school was housed in School No. 1. The boys' basketball team had no practice area. Pictured, from left to right, are George Doublier, Palter Brill, John Kuhnast, John Kerwien (who later served as mayor on the death of his father, Arthur), and George Price (later a well-known cartoonist with the *New Yorker* magazine). They lost all their games but had a never-say-die spirit.

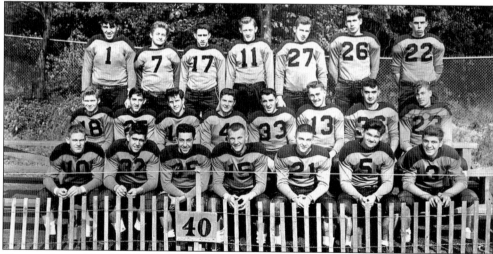

The members of the 1949 high school football team are, from left to right, as follows: (first row) Joe Boylan, Charlie Allen, Tony Macri, Bob Habeck, Mickey Napoli, Bill Chambers, and Anthony Pentifallo; (second row) Guy Farmer, Bob Meyer, Loren Anderson, Charlie Ayers, Eddie Truscelli, Charlie Finnocchiaro, Tony Favara, and Henry Politz; (third row) George Karayanis, Carl Perleberg, Jose Gonzales, Bill Thoms, Jim Collum, Artie Siccardi, and Charles Tiernan.

46

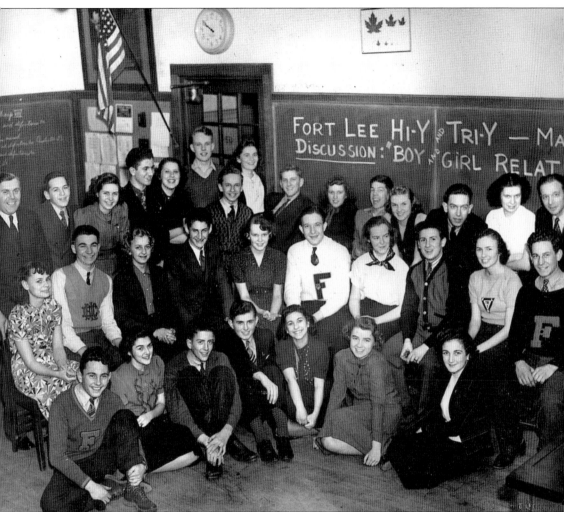

Hi-Y (boys) and Tri-Y (girls), organizations affiliated with the YMCA, were active at Fort Lee High School. Their objective was to develop a stronger character among their members and to project moral leadership throughout the school. The organizations fostered both school spirit and social skills. Participants at Fort Lee High School in 1938 were Raymond Heus (president of Hi-Y), Harry Wright, William Smith (vice president of Hi-Y), Andre Chevaley, Nicholas Noolas, Stephen Ortlip, Betty Bridenburg (president of Tri-Y), Theresa Lyons, Marion Engel (vice president of Tri-Y), Florence Heimberg, Marion Scheumer, and Barbara Dempster. Faculty advisors were O. Howard Miller, Nellie Oettel, and Esther Anderson. Among the activities of the organization were distributing toys at Christmas, maintaining campus bulletin boards, and ushering at special events held at the high school.

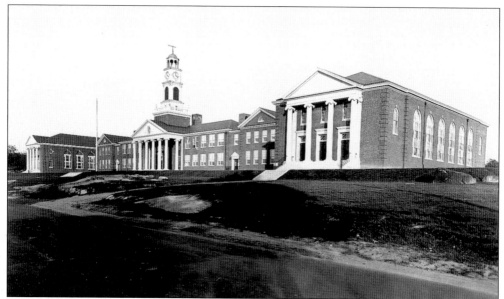

Fort Lee High School was opened in 1929. Until then, high school classes were held in School No. 1, on Whiteman Street. Before 1916, Fort Lee students who wanted to attend high school were sent to surrounding towns that had high schools. The building on Lemoine Avenue was designed to accommodate 800 pupils. The school, designed by the local architectural firm of Sibley and Licht, cost $675,000 to build.

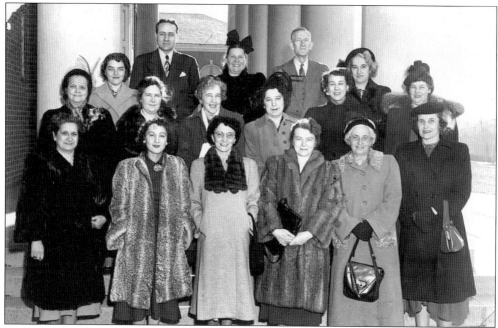

The members of the 1949 high school Parent-Teacher Association are, from left to right, as follows: (first row) Mrs. D. S. Ostuni, Mrs. J. Sorrentino, Mrs. J. K. Crandall, Mrs. I. N. Schnoll, Mrs. S. Grant, and Mrs. V. Brunteson; (second row) Mrs. E. Bridenburg, Mrs. M. Kuhlman, M. Brady, Mrs. W. C. Gardiner, Mrs. J. L. Brown, and Mrs. H. Steger; (third row) Mrs. M. R. Brauer, L. Cole, Mrs. E. Leuthner, Edward Bridenburg, and Mrs. S. Schoenharl.

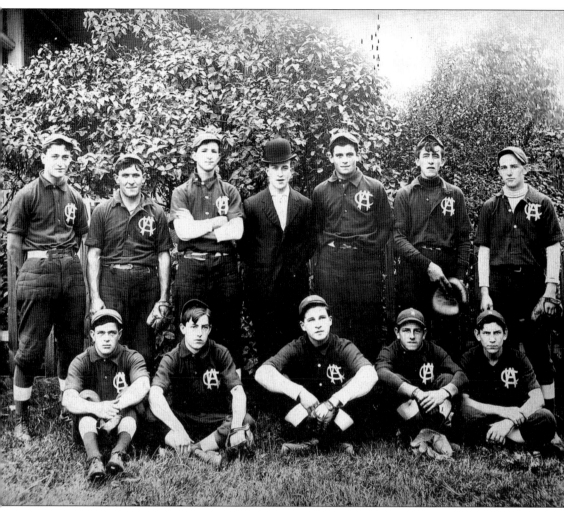

The Hudson Athletic Club baseball team was an early Fort Lee baseball team. In 1907, it won the Fort Lee championship handily. When the Fort Lee Athletic Club was formed in 1910, many of its charter members were from the Hudson team. Baseball was the major sport in Fort Lee at the time and remained so well into the 1940s and 1950s. At various times, the Palisade, Coytesville, and West Fort Lee sections each had their own teams. The teams played each other and teams from around the county. The major field was the Star field, in what is now the Bridge Plaza area. Pictured, from left to right, are the following: (first row) "Skip" Broome, Bill Brannigan, Herb Hayek, John Langsdorf, and William Beuchler; (second row) Bert Graser, Luke Frate, Rudy Garoni, Bill Graser (manager), Raymond Cairola, James Smith, and Paul Cella.

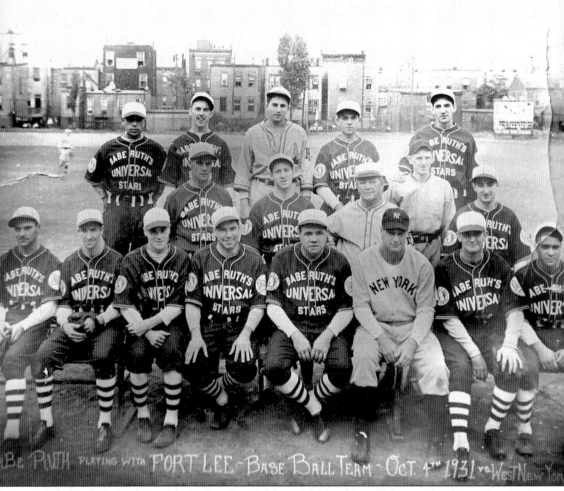

Babe Ruth teamed up with the Fort Lee Athletic Club and Lou Gehrig with a West New York team in October 1931 for an exhibition baseball game. Before a crowd of 8,000 people, Fort Lee jumped to a 3-2 lead, which they held into the seventh inning. The Fort Lee team was defeated 7-4. Pictured, from left to right, are the following: (first row) Billy Cella, George Whipple, Pete Appel, John Pagano, Babe Ruth, Lou Gehrig, ? McCaren, and Tony Mangano; (second row) Paul McCaren, Sonny Sneath, Bill ? (coach), Charlie Subinski, and Leo Devincentis; (third row) ? Gingerella, Frank Oceank, Leon Heller, Babe Maisano, and Emil Schwab. Cella and Gingerella were the pitcher and catcher, respectively. George Whipple became a banker with the First National Bank of Fort Lee. Babe Maisano had the potential for a promising baseball career but was plagued with injuries. He became the owner-operator of Babe's Taxi, which still has a baseball as its logo.

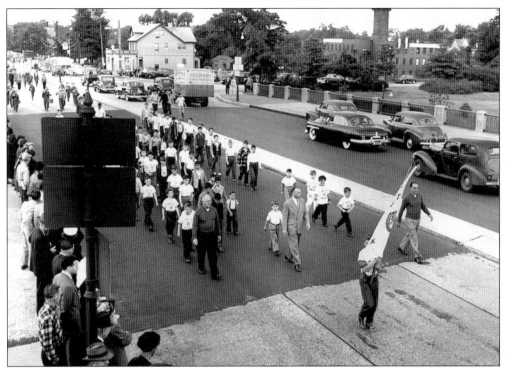

In the late 1940s and early 1950s, the Police Athletic League (PAL) was one of the most important youth organizations in town. This view of the Bridge Plaza, looking south on Lemoine Avenue, shows Police Chief Fred Stengel (in a dark sweater, at the head of the left column). In the upper right is the North American Baby Carriage Factory, notorious in the 1940s and 1950s as a gambling location.

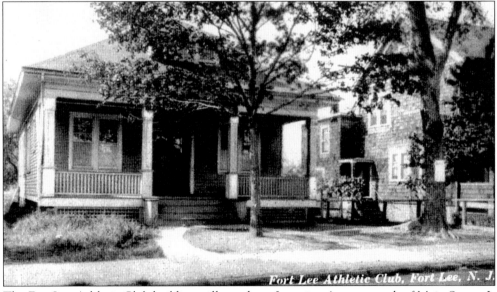

The Fort Lee Athletic Club building still stands on Lemoine Avenue north of Main Street. It was built in 1910. The club owned property behind the building (now the municipal parking lot) that served the citizens of Fort Lee for many years as an athletic field.

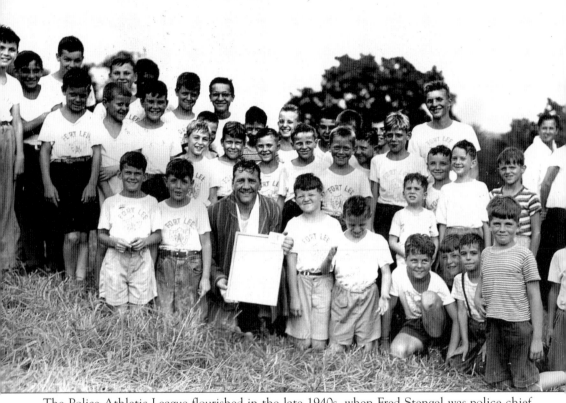

The Police Athletic League flourished in the late 1940s, when Fred Stengel was police chief. Among the activities were boxing matches, soapbox derbies, and the annual Ragamuffin Parade. Shown here are, from left to right, the following: (kneeling) unidentified, Ed Cassidy, Gus Lesnevich, Harry Hawkins, unidentified, Jerry Whooley, unidentified, Tommy Schnackenberg, and two unidentified; (standing) Skippy Hart, John Maggio, Billy Lee, Robert Pauli, Billy Birch, Mickey Villano, unidentified, Billy Quinn, three unidentified, Dominick Conanico, three unidentified, Jim Donovan, Joe Kelly, Artie Schnackenberg, three unidentified, Michael Cassidy, Billy Whiteaker, Joe Benedetti, Bobby Lyons, Harry Sampson, and two unidentified.

Gus Lesnevich (front row, third from the left), from Cliffside Park, was a noted light heavyweight boxer in the 1930s and 1940s. In 1933, Lesnevich fought Jimmy Calabrese in Fort Lee. He knocked him out in the first round. He retained the world light heavyweight title from May 1941 to June 1948. William T. Birch eventually became a Fort Lee police officer. He was murdered in the early hours of September 4, 1966, while responding to a holdup at a Route 4 motel. The park on Stillwell Avenue is named in his honor.

The Lady Foresters, Pride of Fort Lee Circle 25, was founded in 1909. Pictured in their 1910 production of *Beef Trust* are, from left to right, Sophia Lahm, ? Brome, Kate Merkle, ? Allstadt, ? Kennedy, Mary New, Mary Woods, and ? Lang. The Lady Foresters, while not the social elite, were extraordinary women who balanced their family obligations with service to the community.

Nellie Oettel (back row, second from the left) organized the Junior Bethany Club of Camp Fire Girls at the Bethany Methodist Church *c.* 1920. The Camp Fire Girls' purpose was to "seek beauty, give service, pursue knowledge, be trustworthy, hold on to health, glorify work, and be happy." Nellie Oettel later worked at Fort Lee High School.

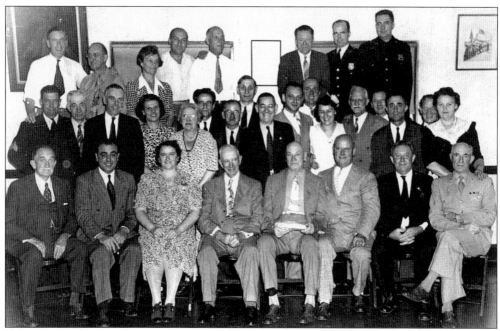

This photograph from 1942 includes many of Fort Lee's officials. From left to right are the following: (first row) unidentified, Rocco Ciccone, Ethel Hill Wiederman, ? Cavanagh, ? Brosnahan, Louis Hoebel, Charles Heft, and Col. Harry Elkan; (second row) ? Meesig (a sergeant), five unidentified, John Henderson, Albert Nelson, unidentified, F. William Aronsohn, John Kerwien, and Josephine Lahm; (third row) Bill Corker, Duke Hart, two unidentified, Walter Williams, ? Hawkins, Donald Weber, and Joe Ennesser.

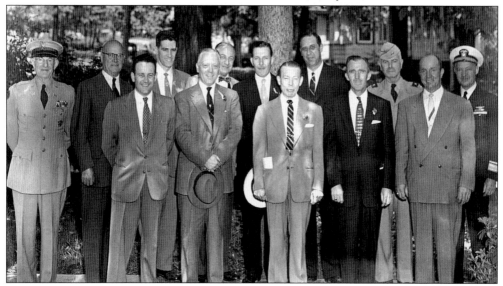

Fort Lee's 50th-anniversary parade dignitaries include, from left to right, Col. Harry F. Elkan, Louis Hoebel, Julius Balestri, Willard Ortlip, John Dahill, unidentified, Paul Van Eyk, Mayor Louis Botjer, Congressman Charles Howell (representing Gov. Robert Meyner), William S. Hart, Maj. Gen. Brendan A. Burns (the grand marshal), John Kerwien, Adm. Lester T. Hunt. Burns and Hunt were Fort Lee natives who returned for the golden jubilee.

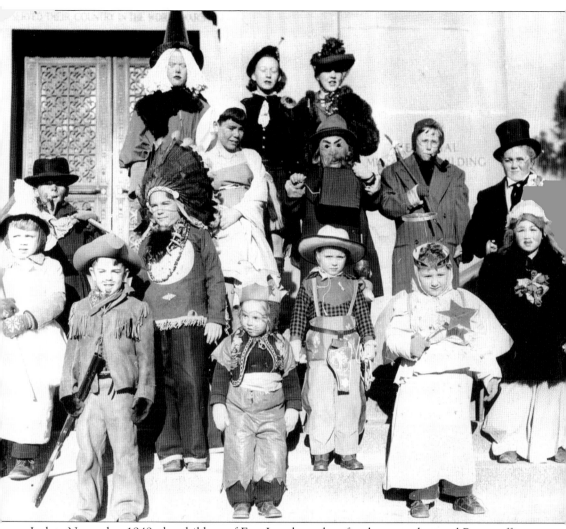

In late November 1949, the children of Fort Lee dressed up for the second annual Ragamuffin Parade. The parade, sponsored by the Police Athletic League, started at Bigler Street and marched to the municipal building on a very cold, blustery day. Posing on the steps are the parade's prizewinners, an imaginative group of youngsters. Identified are Billy Low as Little Bo Peep (with broom), Diane Entwistle as an angel (with star), Billy Hart as the Veep's bride (with veil and fur coat), Barbara Caire as the organ grinder, Mike Cassidy as Cleopatra (left of organ grinder), Allison Hoffman as a tramp (right of organ grinder), Margaret "Sookie" Hart as the Veep (with top hat), Diana Wrong as the Scotswoman, and Beverly Bracket as the green witch (tall hat). Also pictured are Adele Vincenz, Suzy Schaefer, Tom and Ann Dames, and Paul Marahens. Hot dogs and birch beer were served after the parade.

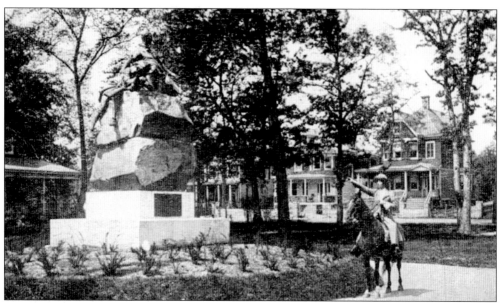

Gowongo Mohawk, on horseback, led a contingent of schoolchildren in the 1908 parade dedicating Fort Lee's Revolutionary War Monument. She was a Native American playwright and actress who toured this country and abroad for over 20 years. She was touted as the country's only Native American actress. She lived in Fort Lee with her husband, Charles. They are buried in the Edgewater Cemetery.

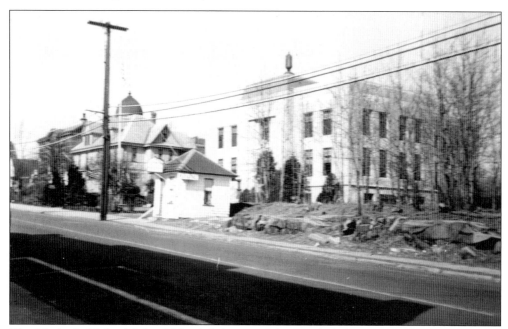

The Mother's Club of School No. 1 (whose members included women with the last names Naudet, Waller, Wasserman, and Fischer) began collecting books for a library in 1919. The collection was housed in a small real-estate office on Lemoine Avenue. In 1922, the borough built a small building for the library at Main Street and Center Avenue. In 1930, the library moved into the new municipal building; the small building became a real-estate office.

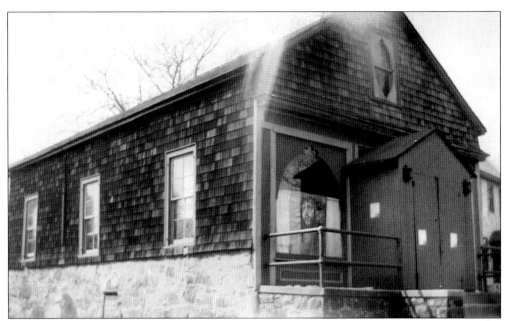

The Reverend Ralph Hoyt came to Fort Lee in the 1850s and established a small Episcopal mission. In the 1870s, he suffered ill health, and his congregation disbanded. This small building, which is still on Main Street, is said to be Hoyt's church.

Taylorville Methodist Episcopal Church was erected in 1867 at Main and William Streets. The Taylors were early members of the congregation. The church disbanded in 1889 and reopened in 1904 as Bethany Methodist Church. The building has been renovated several times. In 1909, a Sunday school was added, and in 1950, a stained-glass window was installed. The church is listed in *The Bergen County Historic Sites Survey 1980–1981*.

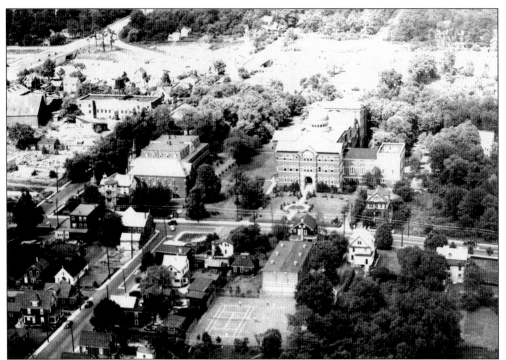

This 1930s aerial view of Main Street, Linwood Avenue, and Anderson Avenue provides an interesting view of an area in transition. The small white building with the cross is the Advent Lutheran Church, on Jane Street. North of Main, on Linwood, are movie studios, one with a water tower. The Anderson home, torn down in 1940, is visible on the Holy Angels' property, at the intersection of Main and Linwood.

In the early 1930s, the small Jewish population held Sabbath and Holy Day services in the Michaelson home on Sixth Street, Coytesville. Mr. Michaelson donated the Torah. Harry Margulies, Coytesville's memorable pharmacist, was an original member. Jewish services were later held at the Church of the Good Shepherd on Palisade Avenue. In the early 1950s, the Jewish Community Center, on Anderson Avenue, was built to accommodate the growing Jewish population.

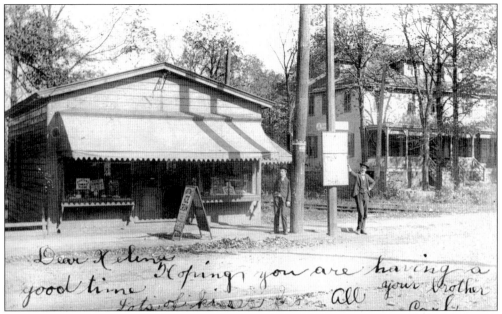

This is Main Street *c.* 1905, where the main post office is now located. The trolley to Coytesville ran between the two buildings: a candy store (left) and Ferrando's Hotel (right). The trolley to Englewood ran west along Main Street. Ferrando's featured a bowling alley and, for a while, a movie theater. Ferrando's sold the property to the federal government for $52,000.

Richters Pharmacy was located on Main Street across from Parker Avenue. A room attached to the pharmacy held the post office for a number of years. Charles E. Richter was postmaster from 1876 to 1892, when the position was taken over by his son Carl L. Richter, who served in that capacity until 1924. Home delivery of mail did not start until 1921. Carl Richter was founder and president of the First National Bank of Fort Lee.

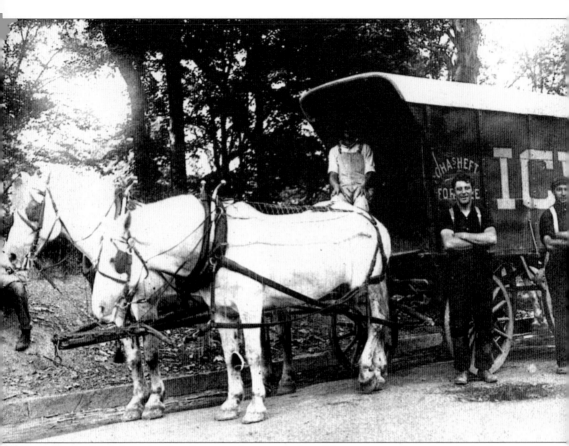

Charles Heft Sr. owned and operated an ice and coal business, conducted with the horse and wagon pictured above. The Heft family—Charles and his wife, Annie, with children Charles Heft Jr., Eugene, and Irma—lived on Water Street, later renamed Hudson Street. The elder Charles was an early Fort Lee pioneer who helped found the Fort Lee Fire Department. He later became chief. Eugene Heft also served as chief. Charles Heft Jr. later ran a moving business. He served as mayor from 1940 to 1951. His platform was for honest and upright government, lower cost of bus fares to New York, and negotiation to lower the rate of local bonds. It was local legend that he was strong enough to lift and move a piano on his own. He lived at 1617 Lemoine Avenue.

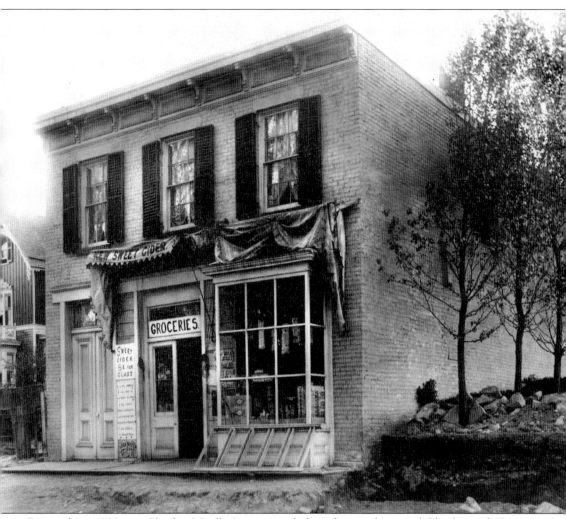

Pictured in 1909 are Charles Mueller's store and the adjacent home of Charles and Kate Lebright, at 1640 Palisade Avenue. The Lebrights were born in Germany. The store was located on Palisade Avenue just south of Main Street. Mueller, also a German immigrant, was in business in Fort Lee before 1900. Mueller's daughter May married carpenter James Sheehan, and they lived above the shop for many years. James later worked in the motion-picture industry. Charles Lebright Sr. was a saloonkeeper. His son Charles Lebright Jr. was a reporter for the *Bergen County Democrat* and several New York newspapers, including the *New York Herald* and the *Evening Mail*. He served as borough clerk for 19 years and was a member of the Lions Club. Charles Lebright Jr. married Rose Brosnahan, from an old Fort Lee family.

Pictured is Main Street at Eickoff Street c. 1910. Eickoff was renamed Gerome Avenue for Gerome Sardi. On the left is McNally Brothers, funeral directors and embalmers, founded in 1891 by Thomas and James McNally. A 1908 advertisement states that the company provided "first-class, rubber-tired coaches for all occasions."

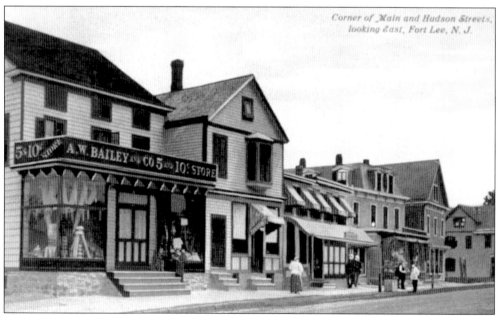

Corner of Main and Hudson Streets, looking East, Fort Lee, N. J.

The A. W. Bailey store stood at the corner of Main and Hudson Streets. The building no longer exists. Hudson Street is now part of Martha Washington Way. The third building from the left is Peter Diehl's saloon. To the right of Diehl's is the Steinmetz dry goods store.

The intersection of Main Street and Palisade Avenue is pictured in 1912. The trolley from Edgewater turned on to Main Street and ran west. The 1911 Sanborn fire insurance map shows three hotels from Palisade Avenue to Bigler Street: Fort Lee Hotel, Schules, Burke's, and (directly on Bigler) the old Bigler Hotel. Note the fire alarm halfway down Main Street on the left. The firehouse is across the street.

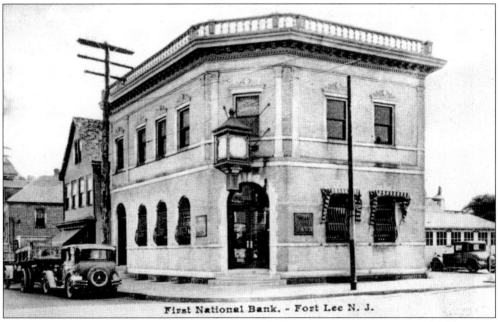

First National Bank. - Fort Lee N. J.

The First National Bank of Fort Lee was established in 1907. In 1912, a new building was erected on the southeast corner of Main Street and Palisade Avenue. Much renovated, it still stands today. Among the early directors were John C. Abbott, Dr. Joseph Huger, Herman H. Ghent, Cornelius Doremus, Daniel McAvoy, Carl L. Richter, Joseph Schlosser, and Charles DuBois. Abbott and McAvoy both served as mayor of Fort Lee.

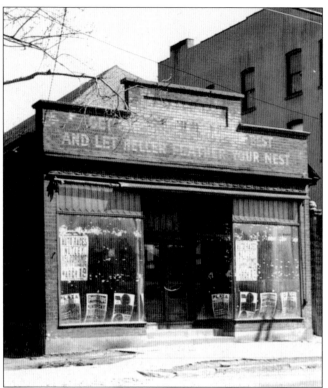

Heller's Furniture Store, on Main Street, is pictured in 1938. The site was the location of Ferrando's, the first movie theater in Fort Lee. The theater was converted from an old schoolhouse. The Heller's slogan was "Get the girl you love best and let Heller feather your nest." The post office parking lot occupies the site today.

Lemoine Avenue, from Main Street north to the Bridge Plaza, was the location of a number of fine homes. To the right of the old Fort Lee Trust Company at Main and Lemoine is the former home of Francis Doublier, one of Fort Lee's early film pioneers. The Doubliers lived there through 1950. The home was torn down, and the Fort Lee Savings and Loan was built on the site.

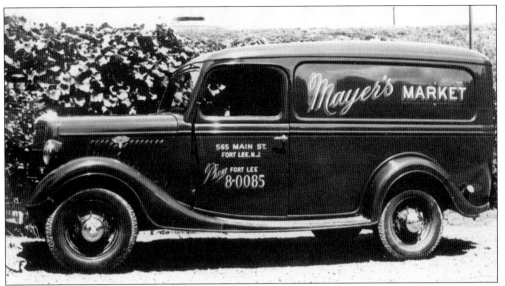

Members of the Mayer family ran a grocery on Main Street for many years. The Mayers' son Chris took over the business and turned it into a liquor store. During World War II, Mayer was in the Coast Guard. He was one of Fort Lee's longest-serving firemen. He served in Company No. 3 in West Fort Lee for 57 years. He was chief of the fire department in 1953.

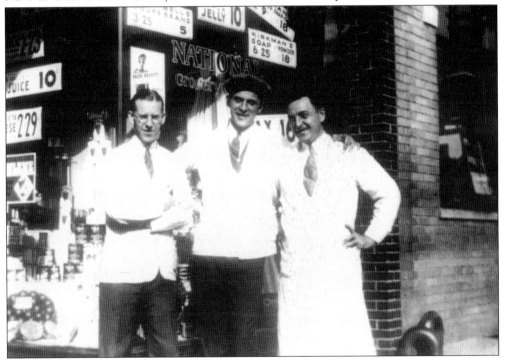

Fort Lee's business community was very hopeful in the 1920s. The Hudson River Bridge promised to bring a bonanza in real estate and a surge in population. Main Street, near Lemoine, would certainly be an excellent location. Harry Holtje (left) managed Palisades Park Lumber and Supply. He later opened Fort Lee Hardware at Main and Gerome. Chris Mayer (center) owned Mayer's Market, and Paul Aust owned the National Grocery Store.

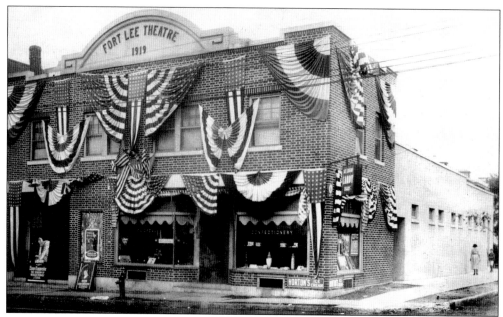

The Fort Lee Theatre, at 250 Main Street (on the corner of Center Avenue), was the borough's second moving-picture house but the first to be built as a theater. The building's gable, with the date of construction, was removed but still exists. For a time, the building housed the Fort Lee Building and Loan Association, Fort Lee's oldest bank. The Veterans of Foreign Wars owns the building, leases the storefront, and occupies the remainder.

In 1919, the Cozy Corner confectionery store was located on the southeast corner of Main Street and Center Avenue before moving across the street. Joseph Gabrick, a Hungarian immigrant, was an early proprietor. Later, Fred T. Pickle owned the ice-cream parlor. It was known thereafter as Pickles. In the 1950s and 1960s, the Arnones owned the store. It was always popular with the after-school crowd.

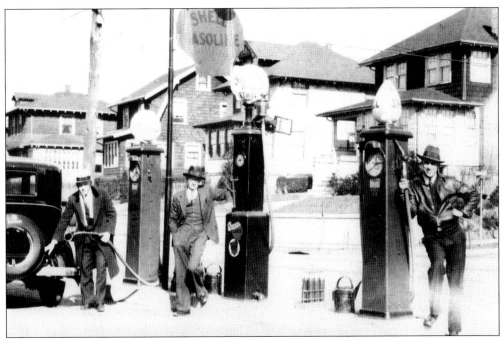

At the Shell gasoline station on Bergen Boulevard, customers in the 1930s could pump their own gas. The main arteries from the new George Washington Bridge began to proliferate in service stations. Some halfhearted attempts were made by the borough council to stop the spread, mainly by raising licensing fees.

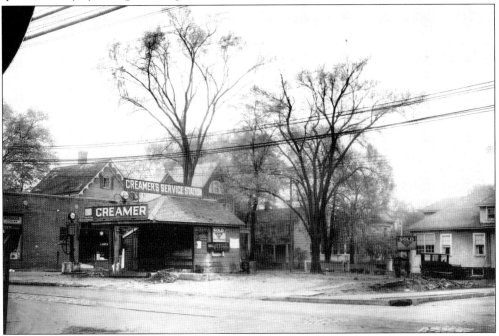

J. Fletcher Creamer Sr.'s Esso station was located at Main Street and Schlosser Street in the 1920s. The Gilvan Company of Teaneck, Fort Lee, and New York put up the sold signs on the property. Later, Gilvan constructed an office and retail structure on the property.

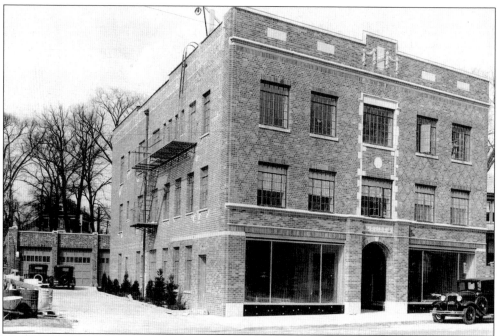

J. Fletcher Creamer Sr. built the Louise office building, with upstairs apartments, at 1605 Lemoine Avenue in the early 1930s. The building was almost completed when this photograph was taken. The Louise was torn down to make way for the Whiteman Street mall. The small, walkup, pre–World War II apartment building was one of the first built in Fort Lee.

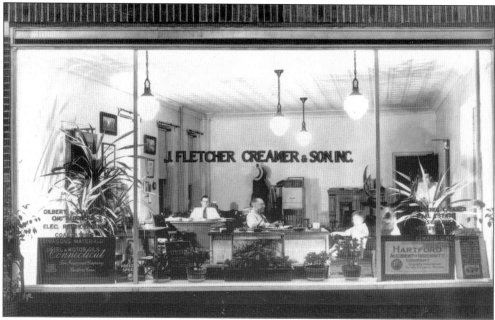

Pictured in their office are three generations of Creamers. The Creamer family was involved in many aspects of Fort Lee's commercial life. According to a 1938 advertisement, the business dealt in real estate, fuel oil, excavation, coal and oil burners, trucking, and mason materials. J. Fletcher Creamer Sr. was also a director of the Fort Lee Trust Company.

The corner of John and Main Streets features some early Main Street storefronts. The style of the building at 484 Main Street (center) has been dubbed Renaissance Revival. The building has a projecting classical cornice and the name V. DeMatteo on the frieze. It was constructed early in the 20th century. Vincent DeMatteo operated the West Fort Lee Market at 482 Main Street.

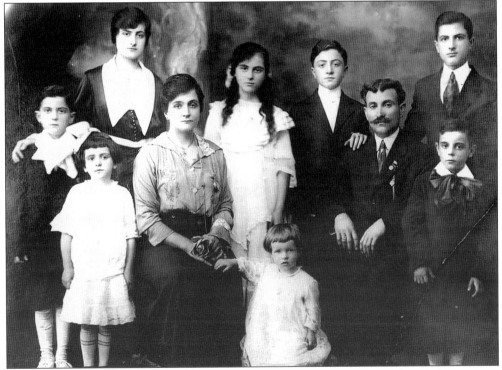

The Napoli family resided on Hudson Street for over six decades. Seated in this c. 1919 photograph are Anna and Pasquale Napoli, with their daughter Edith in front. Standing, from left to right, are August, Dolly, Carmela, Bertha, Henry, Michael, and Nicholas. Napoli was a jeweler, and all his sons followed him into the business. They owned stores in Teaneck, Cliffside Park, and Fort Lee (at 208 Main Street).

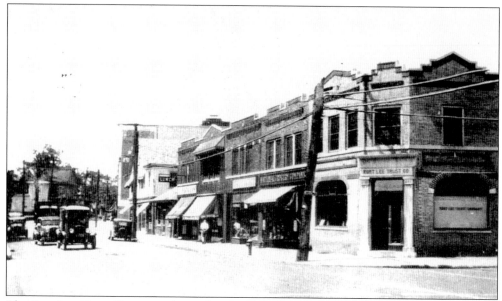

The Fort Lee Trust Company, located at Main and Lemoine, was established in 1922 with J. Fletcher Burdett as president. The board of directors included Albert Bogert, J. Fletcher Burdett, F. J. Mills, Peter Grieb, George Schlosser, Samuel J. Corker, Charles L. Bender, Joseph Cook, James D. Moore, Joseph C. Howell, William E. Wood, William Wunsch, H. L. Coburn, J. A. Riker, and Morris McDermut. The bank started with capital of $120,000.

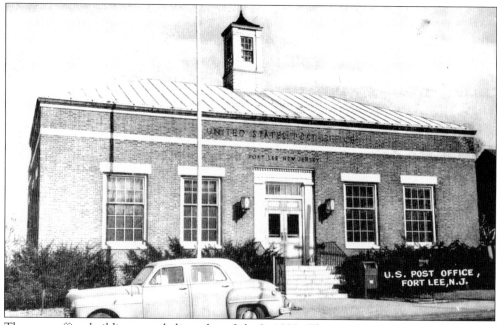

The post office building was dedicated on July 8, 1939. The postmaster was David Skelley. When it opened in 1939, it employed four mail carriers and two clerks. The original post office was established in 1854 with Michael O'Neill as postmaster.

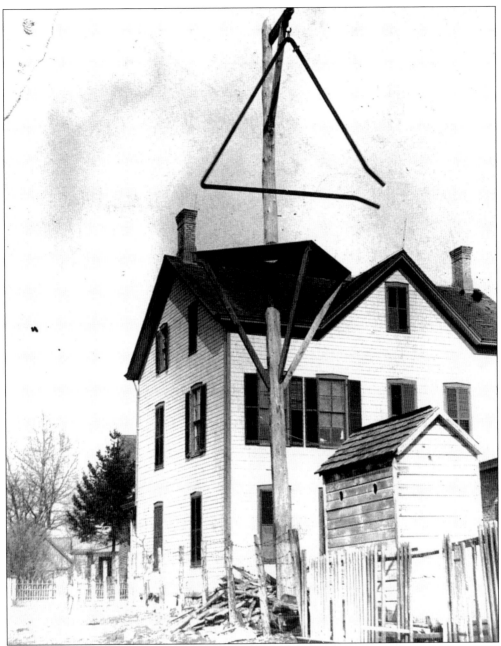

This building still stands at the corner of Main Street and Parker Avenue. It was built c. 1876 and has been altered considerably. After this photograph was taken, the house was raised one story and set on a stone-wall base. At one time, it was site of the First National Bank of Fort Lee, founded in 1907. The bank later moved to a new building at the intersection of Palisade Avenue and Main Street. The iron triangle was the fire alarm. It was placed on a high pole to discourage people from ringing it. The theory was that they would be seen and caught if it was a false alarm. Fire rings were hung at strategic locations throughout the town. When the alarm was rung, firemen would assemble at the ring. They had the authority to commandeer horses to take them to fires.

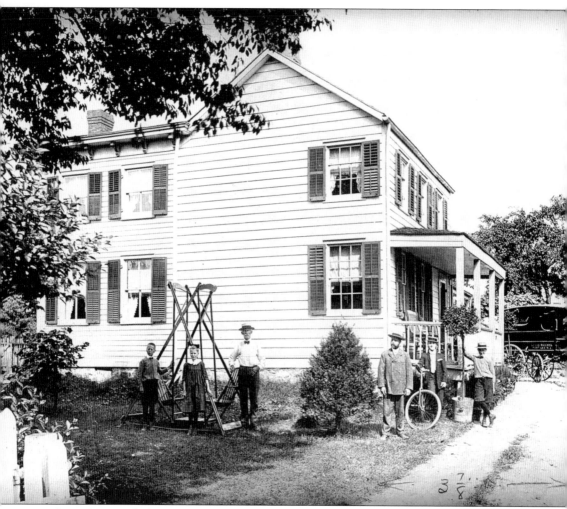

Some 20 years before Fort Lee was incorporated, Hoebel Florists was established in Taylorville (West Fort Lee). This 1890s photograph is of their home on Jones Road. The retail store was first located on Route 6 above Jones Road, then Main Street near Center Avenue, and later on Center Avenue near Main. Until it closed in the 1990s, it was one of the longest-running businesses in the borough. The Hoebel family still lives on Jones Road. The Hoebels produced two mayors and a fire chief for Fort Lee. Louis Hoebel served as mayor and councilman in the 1930s and also served as chief of the fire department. His son Henry served as mayor and councilman in the 1960s and went on to become a county freeholder. The Fort Lee Public Library has been named in his honor. Henry Hoebel was a longtime member of the Fort Lee Historical Society. He was always ready to share stories about Fort Lee, beginning with his discovery as a youngster of a Revolutionary War sword, which is displayed at the society's museum.

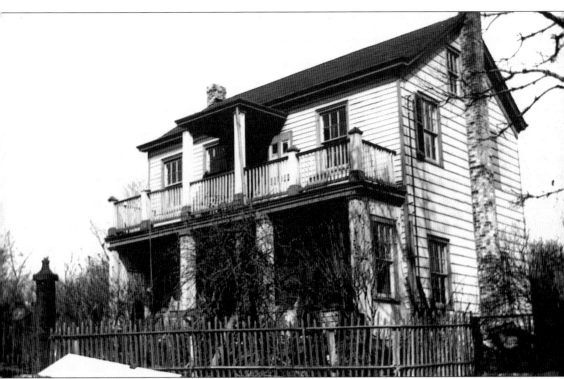

The Allen house, built in the 1860s, was located on Old Palisade Road. Stone pillars graced the entrance. Margaret Allen served for many years on the Fort Lee Board of Education and, in 1953, became the first woman elected president of that organization. She also served as the first executive director of the chamber of commerce and was a founder of the Republican Club. She was the first woman to swim across the Hudson River between Fort Lee and Manhattan. Her home is listed in *The Bergen County Historic Sites Survey 1980–1981*. The purpose of the *Sites Survey* was to enable local communities to identify properties of historic interest, to plan for their preservation, and in some cases, to restore the structures. In the 1980s, Fort Lee still had many buildings of historic note. One of the other significant homes was the pre–Civil War Abbott home on Lemoine Avenue. Both the Abbott and Allen houses were razed soon after the *Sites Survey* was published.

The first home on the right was built *c.* 1880. It is listed in *The Bergen County Historic Sites Survey 1980–1981* as one of the best-preserved Empire-style homes in Fort Lee. Regrettably, it was demolished and replaced by an office building. The other two pictured Kaiser-family homes suffered the same fate. In the early 20th century, Center Avenue dead-ended just north of these homes.

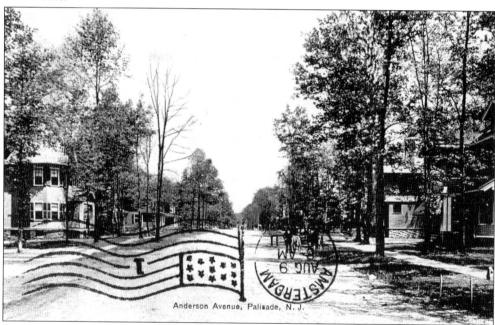

Anderson Avenue, Palisade, N. J.

In 1876, the short stretch of Anderson Avenue was known as Byrnes Avenue. In the early part of the 20th century, the roadway was extended to meet the growing development in the Palisade section. It is now a major thoroughfare and retains many of the homes built *c.* 1910. Homes built south of North Avenue and north of Route 5 were not built until the late 1940s and early 1950s.

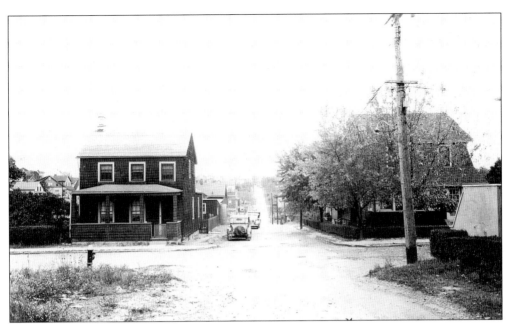

Catherine Street is located in the section of Fort Lee once known as Taylorville. Taylorville is the hollow between Anderson Avenue and John Street south of Main Street. It was named for William Taylor, who in turn named the streets for himself, his wife, Jane, and children, Catherine, Elizabeth, and John. After Fort Lee incorporated in 1904, West Fort Lee gradually replaced the Taylorville name.

Lemoine Avenue is shown in a view looking north from the Bridge Plaza in December 1931. Fort Lee High School is on the right. In the early 1920s, the Lincoln Heights Development Corporation purchased the land opposite the high school. By 1927, the company had added sewers, streets, sidewalks, gas, and water. It advertised the development as "the most valuable spot in the world, superior to Washington Heights." Early lots sold for $1,000.

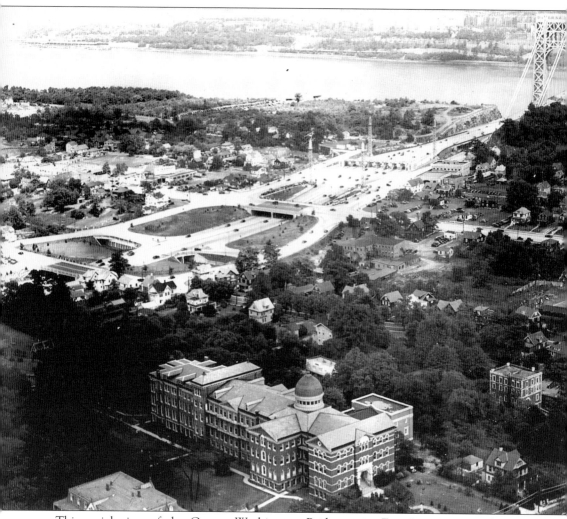

This aerial view of the George Washington Bridge at its Fort Lee terminus depicts the significant change to Fort Lee's landscape the bridge caused. Originally, a traffic circle was planned for the Lemoine Avenue exit from the bridge. The traffic circle concept was not feasible because of the anticipated volume of traffic at the Bridge Plaza. It was not until late in the 1920s that a decision was made that overpasses needed to be constructed at Fletcher, Linwood, Center, and Lemoine Avenues. Officials of the Port Authority of New York and the New Jersey Highway Department also determined an extension was necessary from the bridge roadway to Fletcher Avenue, with a connection to Route 4.

Several former Fort Lee landmarks can be seen in the photograph: the Academy of the Holy Angels, the North American Baby Carriage Factory, and the fieldstone carriage house behind the municipal building. Not one of these buildings stands today.

Three

BOOMTOWN

Palisades Amusement Park came to Fort Lee before the beginning of the 20th century, thanks to the trolley companies that were beginning to lay track throughout Bergen County. The amusement park was begun as an attraction to lure riders to the trolleys. The main trolley lines in Fort Lee ran from the ferry in Edgewater, through the Palisade section to Main Street, and then to Leonia and beyond. Another line ran between Hudson County and Coytesville.

In 1907, a new phenomenon came to Fort Lee. Motion-picture companies in New York City, seeking rural locations at a convenient distance, discovered Fort Lee. Over the next 10 to 15 years, studios and film laboratories were built throughout the borough. Paragon, Solax, Triangle, Universal, and Champion set up headquarters in Fort Lee. Thousands of movies were made in Fort Lee. Many citizens were employed in the movies as actors, extras, carpenters, and executives. Working as extras for $2 a day provided many families in town with some additional income.

The movies and amusement park transformed Fort Lee, literally and figuratively, into a boomtown. Explosions and fires that killed and injured many were an all too frequent occurrence. Both industries provided jobs and, in the case of the movies, an opportunity to grow with a burgeoning industry.

After the George Washington Bridge was completed in 1931, Fort Lee was transformed from a small rural town to a cosmopolitan suburb of New York City.

Fort Lee, from the mid-19th century through the mid-20th century, was home to a number of interesting and sometimes notorious restaurants and nightclubs. The Riviera was the most famous (and, possibly, infamous) of the nightspots, but speakeasies and gambling dens could be found in many locations throughout the borough.

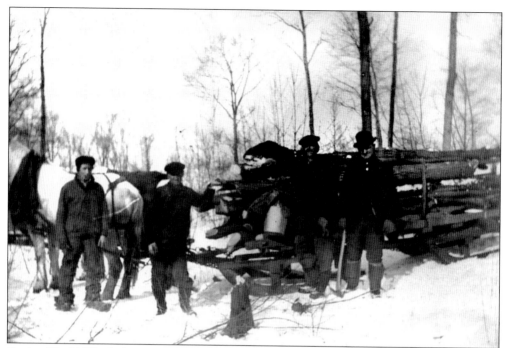

During World War I, the country faced a major coal shortage, which contributed to the exodus of moving-picture companies to the West. Paragon Studios sent out its men to harvest trees from the countryside in an effort to heat the huge, barnlike studios. Fort Lee's much valued bucolic scenery was soon decimated. Among those pictured are George C. Merkle, Antone Ruttemer, and Joe Bailey.

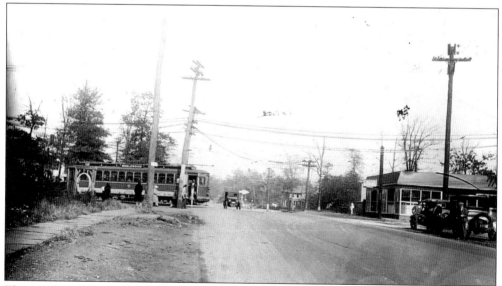

The coming of the trolley lines to Fort Lee in the 1890s precipitated its growth from a rural backwater to a suburban community by the 1930s. The trolleys spurred real-estate development, particularly in the Palisade section of the borough. In the 1930s, the opening of the George Washington Bridge and the proliferation of the motorcar doomed the slow-moving trolleys. Bus lines took over the trolley routes.

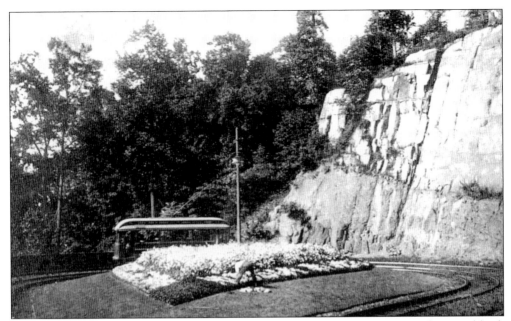

Before 1897, the 350-foot trolley ride up the Palisades from the ferry featured a switchback where the trolley would stop to allow another to proceed. This beautiful horseshoe curve was constructed in 1897 to speed the trip by trolley from the ferry in Edgewater.

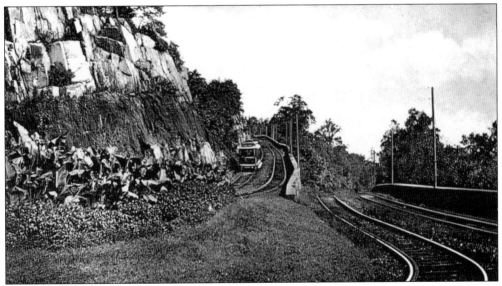

The trip by trolley from Edgewater to Fort Lee was a hair-raising experience. The roadbed for the trolley was blasted out of the Palisades cliff. Trolley companies were involved in land development. As the population increased from new homes, revenues increased for the trolley lines. The Palisade section of Fort Lee owed much of its development to the coming of the trolleys.

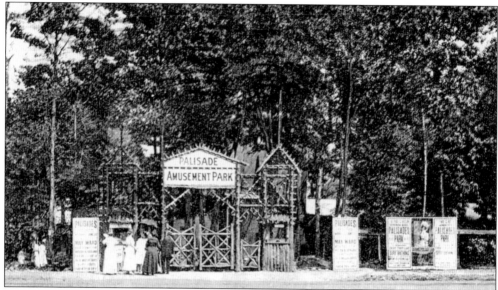

Palisades Amusement Park, established in the 1890s, evolved into one of the best-known, most frequented parks in America. An early manager was Alvin H. Dexter, father of architect Granville Dexter, who designed Fort Lee's municipal building. A 1908 advertisement extolled the park as a "unique amusement enterprise combining the beauties of nature with high-class, selected, and refined amusements."

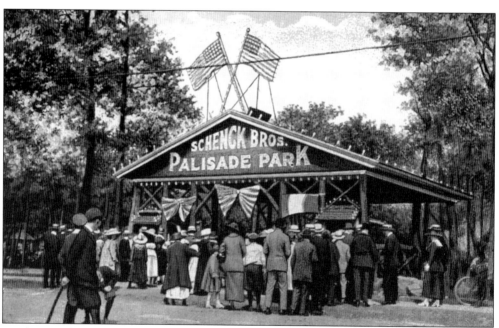

Brothers Nicholas and Joseph Schenck, Russian immigrants, purchased Palisades Amusement Park in 1910. Both brothers became major leaders in the motion-picture industry at MGM and Twentieth Century Fox. The Rosenthal brothers, Jack and Irving, purchased the park in 1935. They continued to operate it until September 12, 1971, when it closed its doors forever.

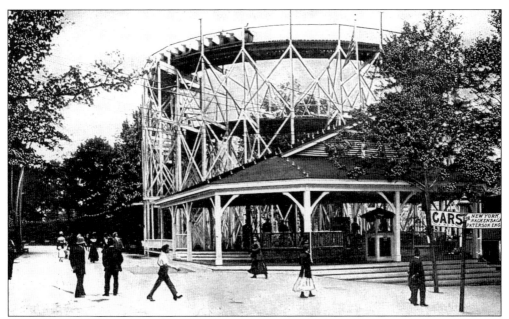

The park's roller coaster cost $25,000 to build in 1910. Over the years, roller coasters remained a main attraction; the names Skyrocket and Cyclone attested to the thrills. The wooden Cyclone, the last incarnation of the coaster, came to symbolize the park because of its visibility for miles around. Roller coasters were also a major nuisance to neighbors, who often complained about the screams coming from the rides.

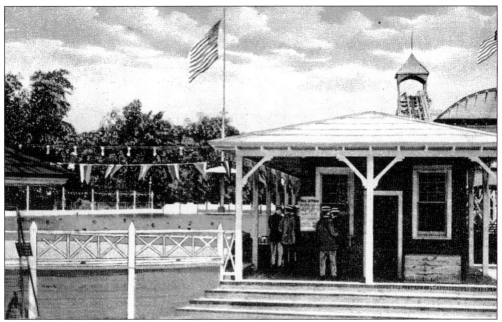

The salt water for the swimming pool at the park was pumped from the Hudson River. The pool was cleaned daily. The cleaners made some extra cash with money found at the bottom of the pool. W. F. Mangels, who helped plan and design rides for the park, devised the wave machine.

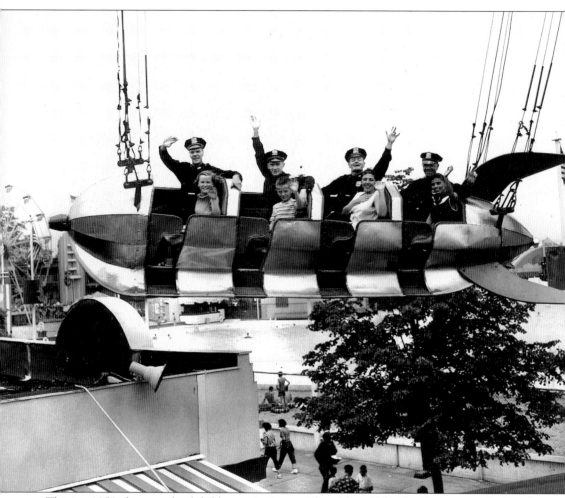

This is a 1950 photograph of children enjoying a rocket ride at Palisades Amusement Park with their Anchor Club hosts. They were among 5,000 disadvantaged and orphaned guests of the Anchor Club, an organization of New York City police officers. The club's slogan was "Be a daddy to an orphan." Charities and civic groups often provided outings for children at the amusement park.

Many of the local children, who did not have the price of admission or who wished to save their cash for rides and food, would gain free admission through a cut in the fence (behind the free-act stage) on the eastern side of the park. It is rumored that Irving Rosenthal knew of the secret entrance and told his security staff to ignore the illegal entries. Irving Rosenthal would reward with a dollar any child who walked up to him and called him "Uncle Irving."

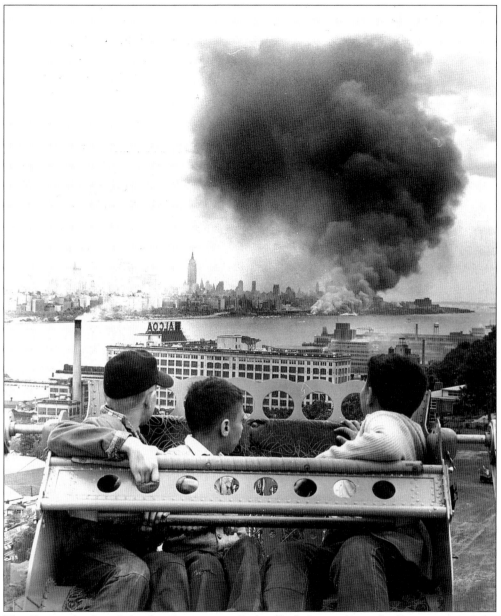

The Ferris wheel at Palisades Amusement Park afforded its riders a bird's-eye view of the Hudson River and New York City. It was advertised as the world's biggest Ferris wheel. Sitting some 300 feet above the river, atop the Palisades, the ride could be seen for miles around. (A pier or ship fire on the river can be seen in the distance.) The park covered 35 acres in the towns of Fort Lee and Cliffside Park. It could boast over 200 rides and attractions in its heyday and attracted millions of visitors each year. The carousel, tunnel of love, funhouse, penny arcade, and saltwater swimming pool were among the popular destinations. There were also live television and radio broadcasts from the park and, at the outdoor stage, top entertainment— trapeze and high-wire acts, animal acts, beauty pageants, movie stars, and favorite local groups. The park also hosted headliners of the music industry, including Rosemary Clooney, Julius LaRosa, Patti Page, and Johnny Raye.

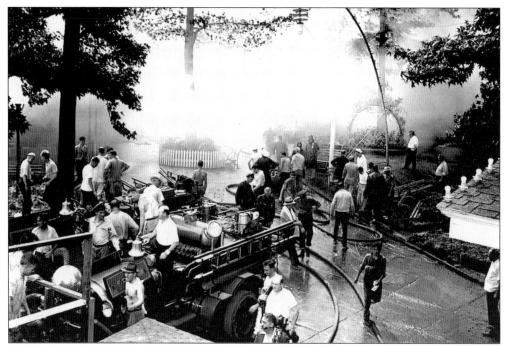

Palisades Amusement Park had several disastrous fires. The worst was in August 1944, when 5 people were killed and over 100 were injured. The fire is believed to have started in a ride called the Virginia Reel. Fanned by high winds, the conflagration was visible for miles around. It threatened nearby homes. Damage was estimated at $500,000.

The park was not fully integrated until the 1950s. As early as 1911, newspapers reported that a black person was denied entrance. By the late 1940s, the park had integrated, but the swimming pool was still restricted to whites. A court fight did not bring integration, as the courts ruled the park was a private entity and could deny admission to anyone.

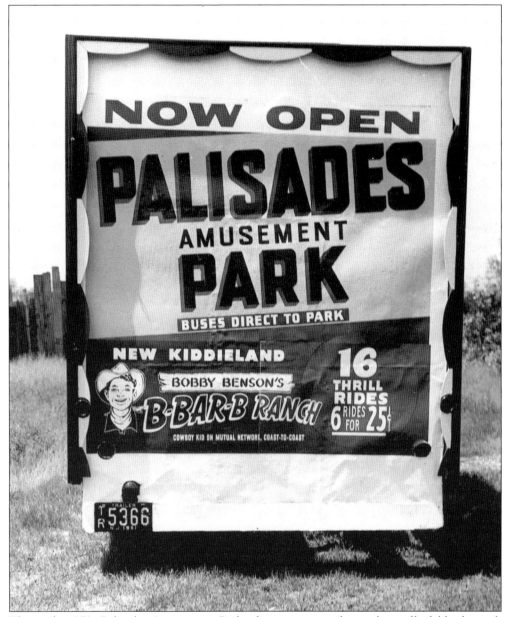

This early-1950s Palisades Amusement Park advertisement indicates how affordable the park was for even the lowest-income families. Admission was minimal; it was volume that made money for the park and its concessionaires. It was also volume that clogged the streets leading to the park, trying the patience of residents. While many parkgoers still used public transportation, the use of the automobile in the 1950s and 1960s became more prevalent. The park property was sold to real-estate developers for $12 million. After the 1971 season, to the dismay of its multitude of fans, the entire park was flattened, and a towering apartment complex and townhouses took its place.

A large gathering of the former park's fans celebrated the 100th birthday on September 26, 1998. A commemorative monument was dedicated at the former site of the park. The plaque on the monument reads, "Here we were happy. Here we grew."

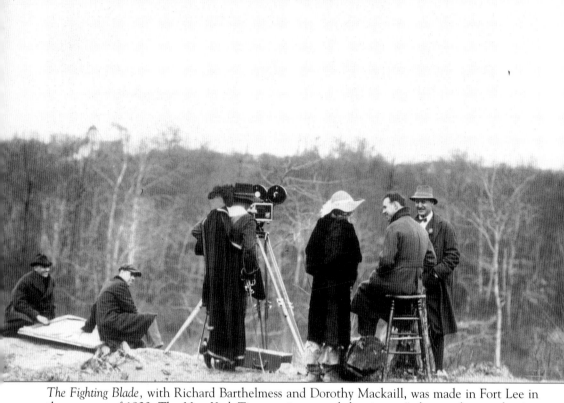

The Fighting Blade, with Richard Barthelmess and Dorothy Mackaill, was made in Fort Lee in the summer of 1923. The *New York Times* review stated that it was "a better class production pictured with sincerity and unusual care" but found the story lacked "life and sparkle." Inspiration Pictures leased the Universal Studios for the production. In the photograph, the actors are looking back at Fort Lee from a bluff on the Palisades. The northern New Jersey area was scouted for homes and scenery that would lend itself to the Cromwellian era that the movie depicted. The East Coast and Fort Lee had not lost hope that the movie industry would return from the West Coast. Fort Lee still had studios to accommodate the making of movies, and the East Coast had the writers, actors, and Broadway productions needed for movie making.

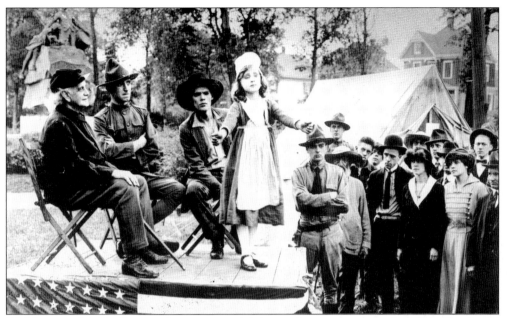

Child actress Madge Evans, who was a model, began her movie career in 1914. She joined World Pictures, which used the Peerless Studios, on Linwood Avenue, for filming. In 1917, Evans appeared in *The Volunteer* with Henry Hull. Evans became a box-office success, one of the studio's biggest stars. She kept World Pictures in the black. This scene was filmed at Monument Park. Some homes in the background still stand.

Pathe filmed *House of Hate*, starring Pearl White, in Fort Lee in 1918. The company often used Fort Lee for its outdoor scenes. Besides the cliffs of the Palisades, the amusement park was also used in White's films. *House of Hate* consisted of 20 episodes and also starred Floyd Buckley. The film, long thought to be lost, was recently found at a garage sale.

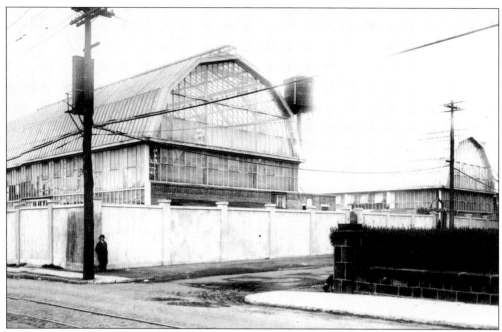

Doc Willat (C. A. Willatowski) built these two studios (also called "Doc Willat's glass barns") at the corner of Linwood Avenue and Main Street *c.* 1914. They were leased in 1915 by Triangle Films and later by Fox Film Corporation. The glass structures allowed natural light, when available, into the studios for filming. Willat, who died in 1937, was also involved in film processing, an important aspect of the filmmaking industry in Fort Lee.

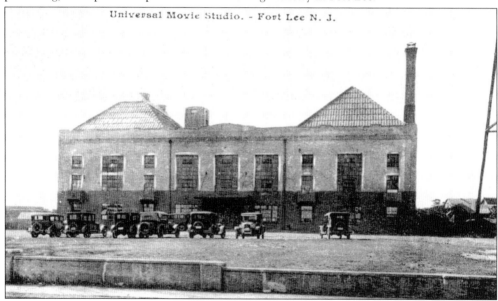

Carl Laemmle established the Universal Film Manufacturing Company in 1912. Champion and Éclair later joined the company. Universal had several locations in Fort Lee, including this studio on Main Street. In 1917, it was leased to Sam Goldwyn for the production of *Polly of the Circus*, his first film. It was later the home of Consolidated Film Industries. The last building on the Consolidated Film lot was torn down in 2003.

Francis Doublier and his wife, Louise Dessenay Doublier, came to the United States *c.* 1902. Doublier, who was born in France, worked as a cameraman for Lumiere Brothers. By 1911, he was employed as chief of the negative department of Éclair's Film Laboratory. Doublier also spent time as manager of Solax and helped establish Paragon in Fort Lee. He also worked for Pathe. His hobby was photography. His home at 2011 Lemoine Avenue was equipped as a research laboratory where he experimented with sound and color. He produced a two-reel documentary entitled *Cinematic Beginnings*, which traces the early history of the movie industry in Fort Lee. Doublier once told an audience that in the early days of the movies, he believed it was a short-termed fad. When he died in 1947, he was vice president of Major Film Laboratories.

The Goldwyn Company filmed *Polly of the Circus*, starring Mae Marsh, in Fort Lee in 1917. It was the newly formed company's first picture. The film was an extravaganza employing almost 1,000 extras. According to Mae Marsh, the filming would often go on late into the night. The *New York Times* gave the film a favorable review.

Constance Bennett made *The Pinch Hitter* in Fort Lee in 1925. Her theatrical parents were Richard Bennett and Adrienne Morrison. In 1906, they purchased property in the Palisade section and lived in their home until 1915. Their daughter, actress Joan Bennett, was born there. In an interview in the *Palisadian*, Bennett said his home was his hobby. They could go horseback riding, and his children could have a country childhood.

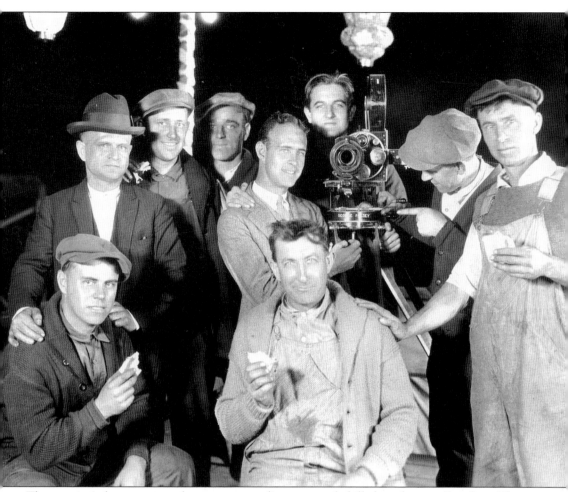

The movie industry attracted many actors, directors, and skilled workers to Fort Lee. The industry also employed many local people. George Folsey (center, at camera) later became a successful cinematographer in Hollywood. In this photograph, painters, carpenters, and electricians surround Folsey. From left to right are Charles Rosenstengel (electrician), unidentified, Dutch Kuntz (electrician), unidentified, Louis Meesig (winder), Eddie Meixner (electrician), Joseph Bailey (carpenter), and Hubert Oates. All of these men were employed by Universal Studios. In a 1918 industrial directory, it was reported that in Fort Lee, the Fox Film Corporation employed 145 people; New York Motion Picture Corporation, 143; Maurice Tourneur Productions, 30; Triangle Film Corporation, 125; and United States Amusement Corporation, 25. Many Fort Lee residents worked as movie extras. One evening, the extras led a small riot when filming of a movie went on past midnight and they had not been fed as promised. When the fighting broke out, the police and home guard were called. Fortunately, there was only one casualty—a local who may or may not have been shot by a member of the home guard.

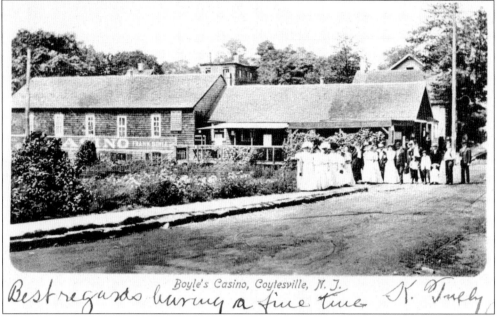

Boyle's Casino, Coytesville, N. J.

Boyle's Casino in Coytesville was located on Washington Avenue near Second Street and the trolley line. It provided dancing (at 10¢ a dance) and a poolroom. The Boyle family, especially James, a contractor, and his brother Hugh helped found and support Holy Trinity Roman Catholic Church.

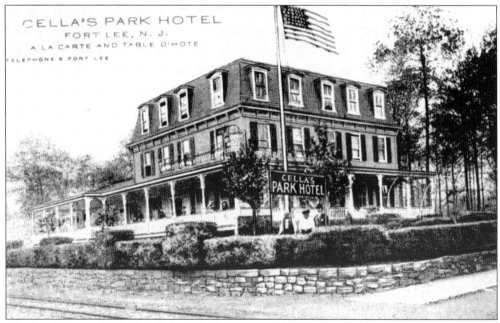

Charles Cella established Cella's Park Hotel at the beginning of the 20th century. His sons Peter and Richard followed him into the business. The hotel provided a convenient meeting place for movie personnel. It is reported that the Screen Actors Guild was founded there. Cella's was the largest hotel in Fort Lee. The hotel was demolished *c.* 1950 to make way for garden apartments.

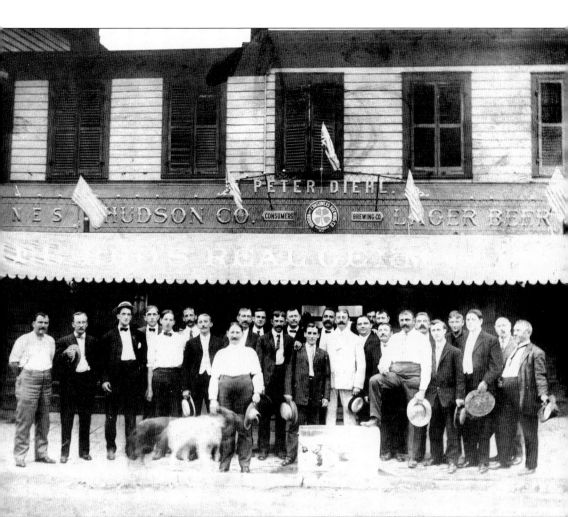

Peter Diehl's saloon was located on Main Street at what is now Martha Washington Way. Diehl lived above the business with his wife, Minnie, and his extended family—stepdaughters Mary and Lillian Edsall, daughters Anna and Marie, and brother-in-law Patrick Conkling. During the influenza epidemic of 1918, Fort Lee churches, schools, and saloons were forced to close for a time by the state department of health. Mayor Edward White gave the saloons a short reprieve, much to the consternation of the clergy. Diehl (the man with his foot on the horse trough) was forced to give up his liquor license during Prohibition. He turned the saloon into a restaurant. He was one of the first to sell property to the Port Authority of New York for the construction of the George Washington Bridge.

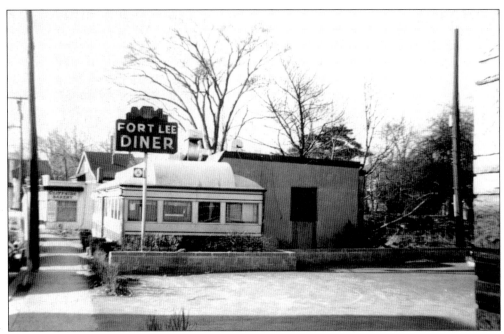

The Fort Lee Diner was a fixture on Lemoine Avenue for several decades. Affable Gus Grossman, the most notable proprietor, kept his business in operation 24 hours a day. It was a popular rendezvous—the place to go after a party, sports event, or meeting, or for a cup of coffee. Grossman was an active and generous member of the local Lions Club. The building has been extensively renovated but still exists.

The New Hudson Villa Restaurant was located on Myrtle Avenue in Coytesville, a few blocks north of the George Washington Bridge. The building is now a private home.

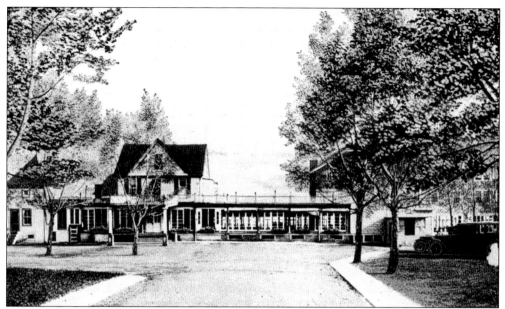

Villa Richard opened in 1909 in Coytesville. The nightclub-restaurant was owned by Jean Richard, formerly chef at New York's Delmonico's. His wife, Julia, was also a chef at the restaurant. In 1927, they divorced. In 1929, the police, on suspicion it was a bordello, raided the club. It was eventually leased to Ben Marden, who called it the Riviera. The building was destroyed by fire in November 1936.

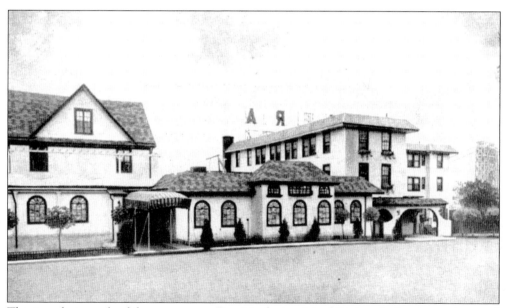

This is a photograph of the entrance to Ben Marden's original Riviera, before it was destroyed by fire. County prosecutors, looking for gambling activities, were constantly raiding the club. It was alleged that Bergen County customers would never be allowed in the rooms where gambling took place. It was reported that during one raid, the police were turned away because they were not in formal eveningwear.

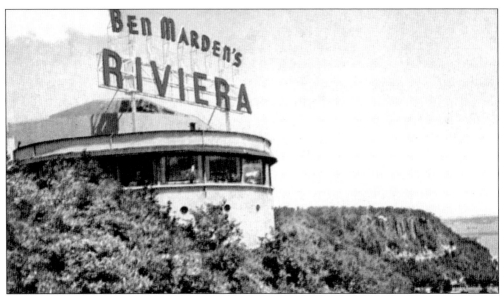

After a disastrous fire in 1936, Ben Marden rebuilt the Riviera farther south on the Palisades and overlooking the George Washington Bridge. The nightclub opened in June 1937, attracting 800 guests. The Riviera featured a domed roof that could be opened. The cost of the building was estimated at $200,000. During winter months, the club closed and Marden operated a club in Cuba.

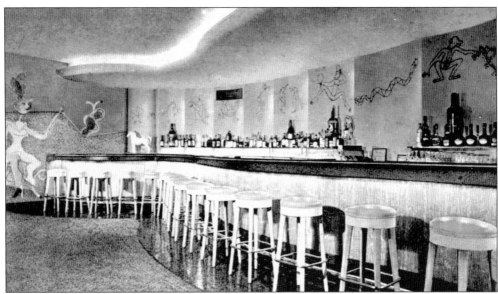

Arshile Gorky, a Work Projects Administration artist, decorated the cocktail lounge and other areas of the rebuilt Riviera with large murals. Gorky was an Armenian holocaust survivor. In 1953, New Jersey condemned the Riviera property to make way for the Palisades Interstate Parkway. The murals were lost when the Riviera was demolished. Gorky also did work for the New York World's Fair of 1939 and Newark Airport.

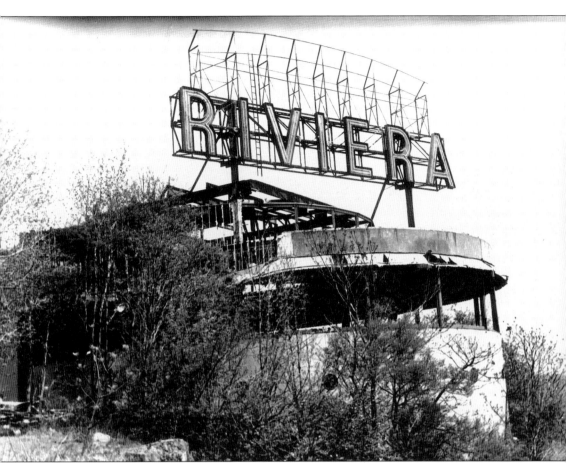

The last show at the Riviera nightclub was held on October 4, 1953. The program on the last evening featured Eddie Fisher and Henny Youngman. Earlier that year, the state condemned the property to make way for the Palisades Interstate Parkway. The parkway would have a direct link to the George Washington Bridge, which would facilitate the flow of traffic and ease congestion by diverting five million cars from local roads, especially Hudson Terrace, Lemoine Avenue, and Route 4. It was originally thought the landmark building would be saved as a tourist site, or as a highway-maintenance building, but the club was demolished later in the year after an auction of its furnishings. The foundation of the nightclub and its parking lot are still visible on the cliffs of the Palisades.

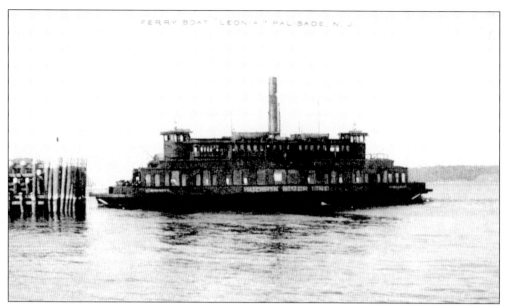

The ferryboat *Leonia* carried vehicles and passengers. It plied the Hudson between 125th Street and Edgewater. Built in 1915, it was steam powered and screw propelled. The ferry measured 177 feet long, 40 feet wide, and 16 feet high. It weighed 923 gross tons.

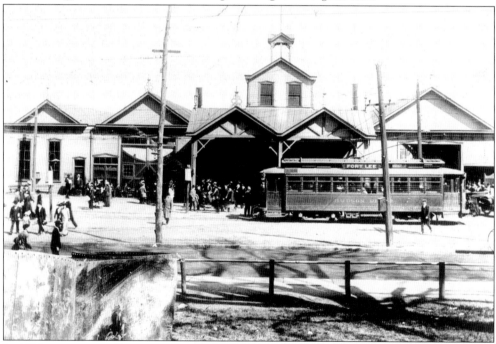

In 1929, over nine million passengers rode the ferries between 125th Street and the Edgewater terminal. This contributed to the development of Fort Lee and much of Bergen County. Trolleys traveled from the terminal up the Palisades, along Palisade Avenue, and then down Main Street toward Hackensack. By 1915, they ran every 15 minutes from 6:00 A.M. to 6:00 P.M., every 30 minutes until midnight, and then hourly until 6:00 A.M. The four ferries operated until 1950.

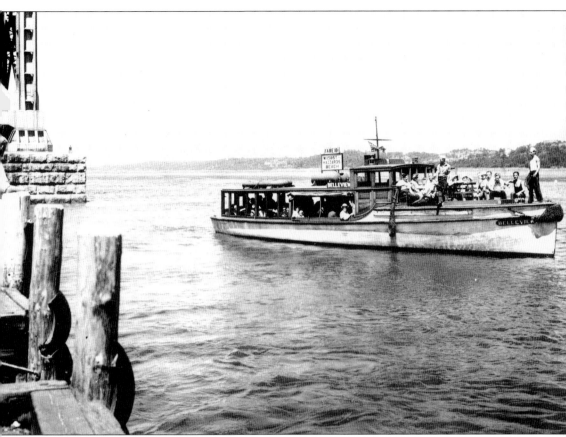

The ferry *Belleview* ran from 158th Street in New York to Hazzard's Beach at the foot of the Palisades in Fort Lee. Construction of the George Washington Bridge necessitated closing the beach and halting ferry service for several years. Hazzard's Beach reopened in 1932, and ferry service resumed for a time. The beach exists today as a small boat-launching area. The area below the bridge features several points of interest. There are spectacular views of the Palisades and the New York skyline from this area. The Shore Trail, which begins just below the George Washington Bridge, extends for 13 miles along the Hudson River to Alpine. To the north of the bridge is Carpenter's Trail, which climbs the Palisades. The area along this stretch of the Palisades is tranquil with breathtaking natural beauty, including several waterfalls. In 1910, the bones of a *Phytosaur clepsysaurus*, a 210-million-year-old dinosaur of the Triassic age, was discovered on the park's Edgewater boundary. The bones are on display at the American Museum of Natural History in the Hall of Vertebrate Origins.

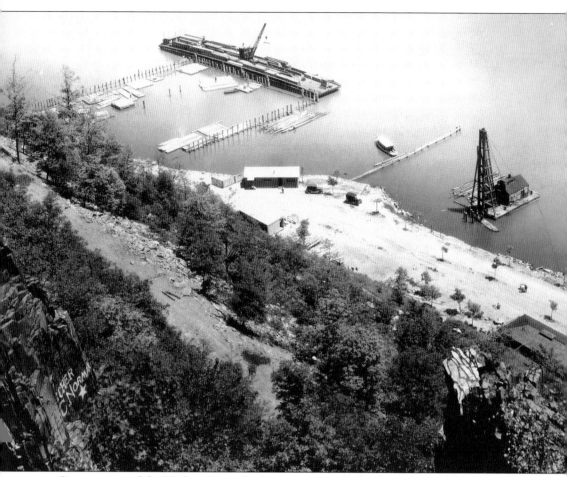

Construction of the Hudson River Bridge, as it was called before its official naming, involved the building of cofferdams. They were temporary, watertight enclosures built 100 feet under the water and then pumped dry to allow pouring of cement for the foundations of the bridge towers. On December 23, 1927, three men working as sandhogs 50 feet below the surface of the water were killed when the cofferdam they were working in collapsed. The blow caused an inrush of water and mud. Several workers managed to escape by climbing a 100-foot ladder to the surface. If the accident had occurred earlier in the day, many more men would have been killed. The victims were working overtime to speed construction. It was the most serious accident during the construction of the bridge.

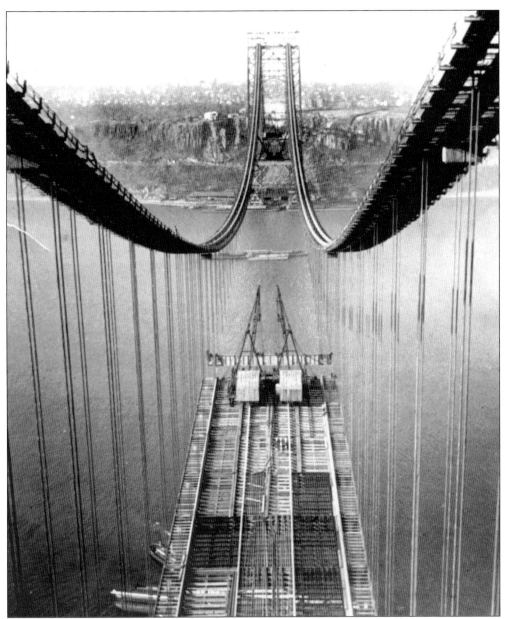

The first cable was stretched across the Hudson River between the newly constructed towers of the Hudson River Bridge on July 9, 1929. It was a temporary cable to enable construction of footbridges that facilitated the construction of the four main cables. In August 1930, the John A. Roebling Sons Company completed the cables. Each of them could carry a load of 350,000 tons. When the cables were finished, the roadway construction (pictured here) was begun. The assembling of the steel for the roadway began in November 1930 and was completed in May 1931. The roadway was completed in the autumn of 1931. It was constructed for eight lanes of traffic. Plans for future development included a lower deck that would carry rapid transit or vehicular traffic. In 1931, the George Washington Bridge's span of 3,500 feet between towers was almost double the length of any existing bridge. The total length between anchorages is 4,760 feet. The bridge's sidewalks are 10 feet wide. A lower level was added in the 1960s.

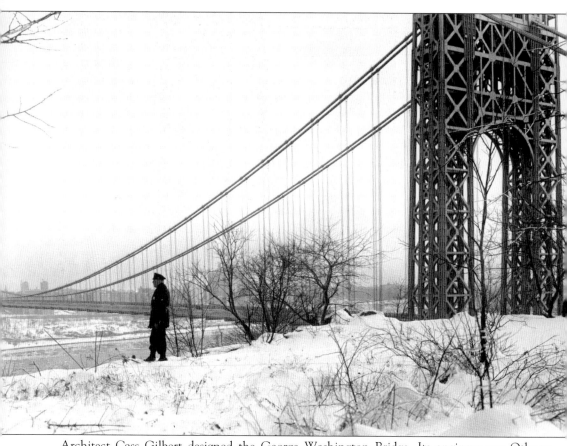

Architect Cass Gilbert designed the George Washington Bridge. Its engineer was Othmar Ammann, who constructed a bridge that was twice the length of any previous span. The building of the bridge was considered one of the greatest engineering feats of its time. The Swiss architect Le Corbusier described the bridge best: "The George Washington Bridge over the Hudson is the most beautiful bridge in the world. Made of cables and steel beams, it gleams in the sky like a reversed arch. It is blessed. It is the only seat of grace in the disordered city. It is painted an aluminum color and, between water and sky, you see nothing but the bent cord supported by two steel towers. When your car moves up the ramp the two towers rise so high that it brings you happiness; their structure is so pure, so resolute, so regular that here, finally, steel architecture seems to laugh."

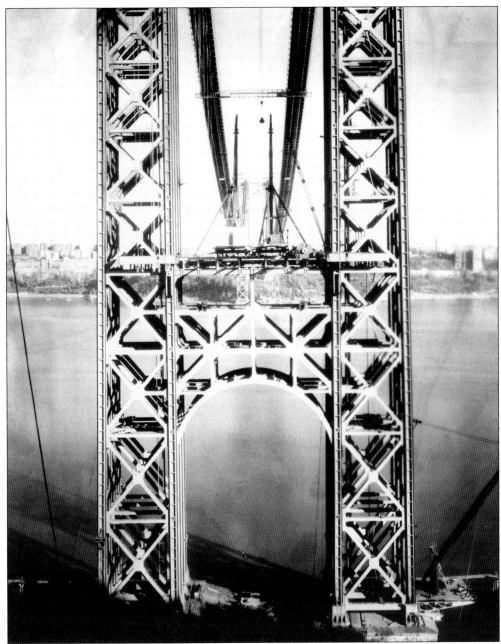

The soaring steel towers, each 12 stories high, were designed to carry the entire load of the bridge. Some 20,000 tons of riveted steel make up each tower. Four 180-ton steel saddles were placed atop each tower. Originally, the towers of the bridge were to be encased in concrete, but it was determined that for economic and esthetic reasons, they be left bare. After the building of the towers was completed, a tramway was constructed as a means of sending equipment and materials from one side to the other. To bring the cables across the Hudson River, two temporary footbridges were built—each one mile long and strong enough to withstand high winds to allow stability for the men working on them. The John A. Roebling Sons Company, which built the Brooklyn Bridge, constructed the cables.

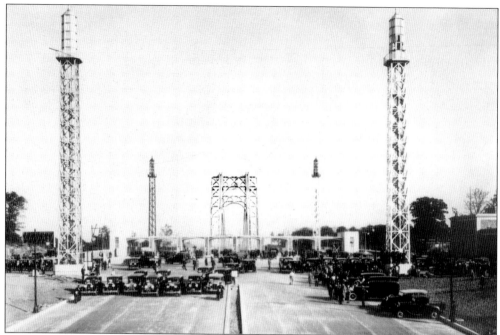

The George Washington Bridge was dedicated on October 24, 1931. The governors of New York and New Jersey attended and spoke, as well as the mayors of New York City and Fort Lee. Fort Lee's mayor, Louis Hoebel, predicted that someday in the future, the small municipalities on the New Jersey side of the bridge would consolidate and Fort Lee would be at the center.

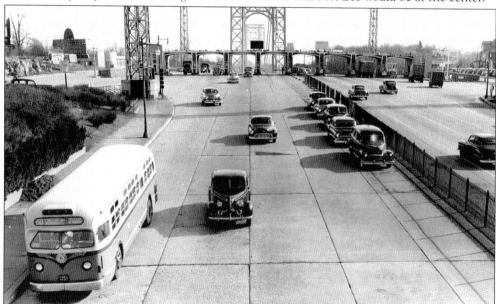

The bridge tollbooths were constructed on the New Jersey side. It was more feasible than to displace many homes and businesses. Tolls were also charged on the pedestrian walkways. It seemed unfair, however, that those walking across the bridge pay the same 5¢ fare as those taking the bus. The pedestrian tolls were eliminated in 1940. It was not until 1943 that women were hired as toll collectors.

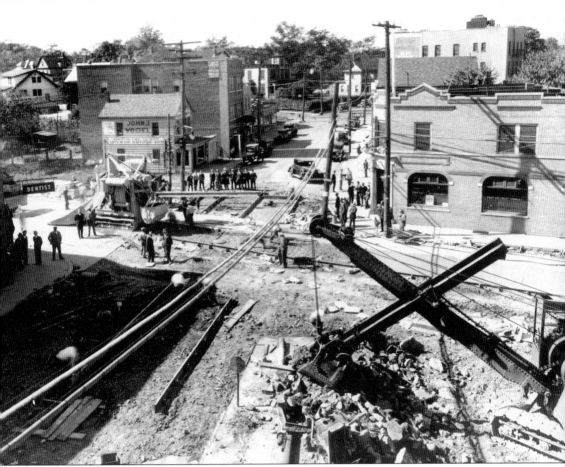

As the George Washington Bridge neared completion in the early 1930s, road improvements and construction speeded up in anticipation of increased traffic. Lemoine Avenue was widened south of the Bridge Plaza, and the roadway extended south from Main Street to intersect with Palisade Avenue. This view of the roadwork shows the intersection of Main Street and Lemoine Avenue. The Vogel building, at 204 Main Street, still stands, although the front is now obscured by an addition. John J. Vogel, originally in the dry-cleaning business, saw an opportunity in the 1920s and went into real estate. In 1927, he advertised himself as the "live wire realtor" and was selling a 50- by 120-foot lot on Main Street for $5,000. In 1930, as the Great Depression deepened, Vogel was selling property three blocks from the bridge at a sacrifice price of $1,500 per lot.

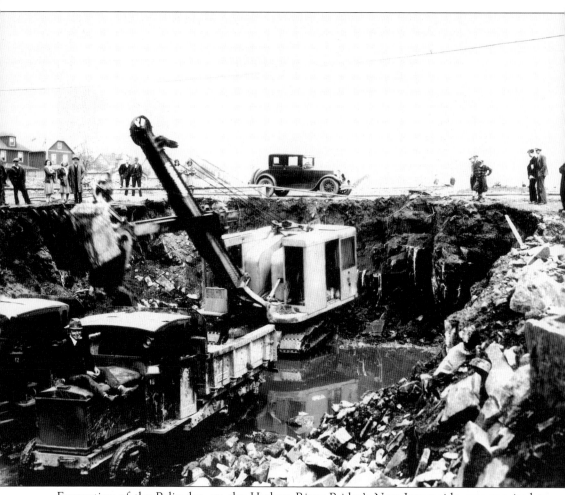

Excavation of the Palisades, on the Hudson River Bridge's New Jersey side, was required to create pits and tunnels to anchor the cables for the bridge. The cut in the cliff, 140 feet wide and 50 feet deep, involved the removal of some 220,000 cubic yards of rock. The George M. Brewster Company and the Maceri and Cutrupi Company were two of the major local contractors on the project. As with many of the contractors participating in the bridge's construction, their work was finished ahead of schedule. Their biggest impediment was nature, in the form of flooding, which caused many delays. The roadway from the bridge was designed to allow connections with new highways being constructed in New Jersey. It was also necessary to build a viaduct over Hudson Terrace. The blasting required to construct the roadway broke many windows in Fort Lee. The contractors paid for the damage.

This view, looking west, shows the trolley lines on Main Street in West Fort Lee before the construction of the Route 46 overpass. Mayer's Market, at 565 Main Street, is on the right. On the left are Frola's Tavern and Cummins Real Estate.

Main Street is seen in a view looking west to the Route 46 overpass in 1942. In the 60 years since this photograph was taken, very little has changed. A traffic light has been added to the busy intersection at Maple and Main Streets, and Fire Company No. 3 is in its new firehouse on Main Street.

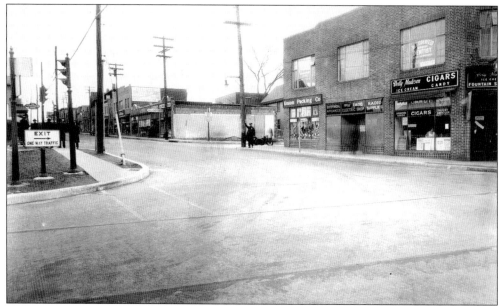

The Gilvan Building, at Main Street and Lemoine Avenue, was constructed at the time Lemoine was extended south from Main Street. The tract of land was purchased by Gilvan Realty in 1928 for $125,000. When completed, the building had 11 stores on the main floor and 13 offices on the second floor. The complex was sold for $140,000 the following year. In the early 1920s, the two properties had sold for $50,000. Schlosser's Hotel was on the site previously.

From Palisades Amusement Park north, Palisade Avenue was lined with hot dog stands and roadhouses from the 1930s to the 1970s. Costa's was selling franks for 10¢ and soda for 5¢. Throngs of weekend motorists passed this way, creating parking, littering, and noise problems. Some road stands served liquor, which created more serious problems.

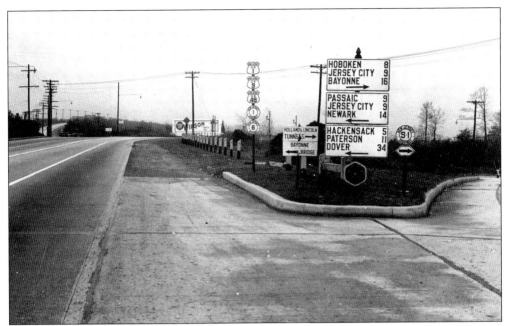

This photograph of the intersection of Route 46 and Bergen Boulevard was taken in 1938. Bergen Boulevard exits to the right and is visible again in the upper left. The New Jersey State Highway Commission built two new major highways in Fort Lee because of the traffic generated by the George Washington Bridge: Routes 4 and 6. Route 6 was later merged with Route 46.

Route 4, seen in a view looking east from Myrtle Avenue in 1937, opened to traffic on January 21, 1932, a few months after the George Washington Bridge opened. Initially, motorists could travel only from Fort Lee west to Grand Avenue in Englewood. The final phase through to Paterson was completed six months later.

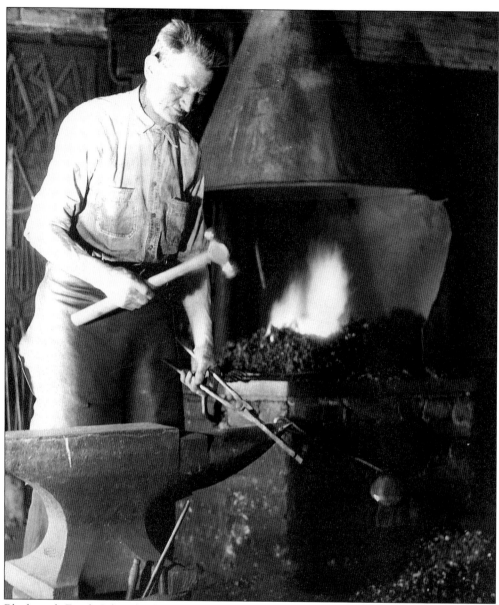

Blacksmith Frank Schmidt plied his trade for many years in Coytesville. He and his wife came to Fort Lee before 1905. They made their home on Sixth Street in Coytesville until their deaths. The Aluminum Company of America in Edgewater employed Schmidt until his retirement in 1946. He is pictured wearing a protective apron with some of the tools of his trade: anvil, forge, and hammer. There were at least three blacksmiths in Fort Lee in the 20th century. Two were in Coytesville, and the other was located at Main Street and Palisade Avenue. The second Coytesville blacksmith was James Haggerty, who lived on the corner of Washington Avenue and Third Street. Haggerty was born in Coytesville to Patrick and Winifred Haggerty, Irish immigrants who came to the United States in 1870. He lived all his life in their home, which still stands. Haggerty's business premises stood opposite the Coytes' post office on Washington Avenue. In a boycott against the industry that caused him to lose his business, James Haggerty never owned an automobile.

110

Four

PALISADE AND COYTESVILLE

Coytesville, in the north end of Fort Lee, and Palisade, in the south section of town, are a study in contrasts within the community.

Historically, Coytesville is the oldest. It has narrow, steep roadways laid out in a strict grid pattern. Joseph Coyte, who originally owned property from the Palisades to Overpeck Creek, founded it in the mid-1840s. Coyte donated land for Coytesville's school, ran the general store, and built homes. He encouraged shoemakers to come to the hamlet, and for many years, they operated a cooperative. Coytesville, through much of the early 20th century, was Irish and Catholic. Hotels were established throughout Coytesville during the 19th and early 20th centuries. Many residents worked as laborers for quarrying companies.

In contrast, Palisade was wooded and largely unsettled until the 20th century. The Hudson River Realty Company purchased large tracts of land, laid out large improved lots, and built some homes. Palisade, built between the cliffs of the Palisades and the valley west of Fort Lee, is curvilinear in its road pattern. The company donated land for a nondenominational church and for a school. Palisade's early residents were often wealthy commuters.

Long before the advent of the movie industry in Fort Lee, Coytesville was home to a small cadre of actors and show people. Best known was Maurice Barrymore, who helped raise money for the Coytesville firehouse. Palisade also had a well-known acting family, the Bennetts—Richard, his wife, and their daughters, Barbara, Joan, and Constance.

Joseph Coyte donated Coytesville Park, located on the Palisades overlooking the Hudson River, to the people of Coytesville. The Palisades Interstate Park Commission took the land for the new parkway in the early 1950s. The commission later donated other land for parks in Coytesville. The Allison estate had donated the land to the commission "to be used perpetually for the glory of God and benefit of mankind."

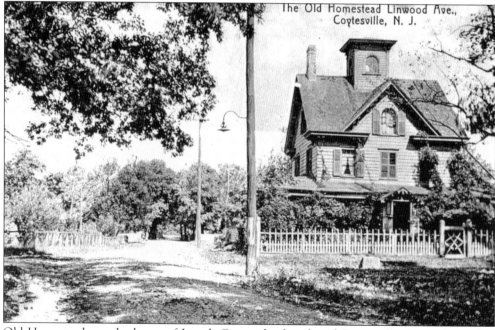

Old Homestead was the home of Joseph Coyte, the founder of Coytesville. It was located at Westview Place and Linwood Avenue. Coyte was probably the first real-estate speculator in Fort Lee. Coyte came to the area in 1847 with his wife, Ellen Hall. The Coytes had five sons and two daughters. Their descendants still return to Fort Lee for family reunions.

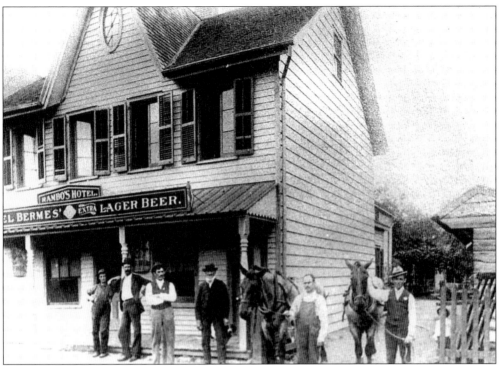

Rambo's Hotel, on First Street in Coytesville, was built in the 19th century. During the period that the movie industry was active in Fort Lee, the hotel served as backdrop, dressing room, cafe, and residence for movie personnel. Gus Becker bought the building in the 1920s, and it became a popular local tavern. The building survived a major fire in 1998 and, much renovated, still exists as a private home.

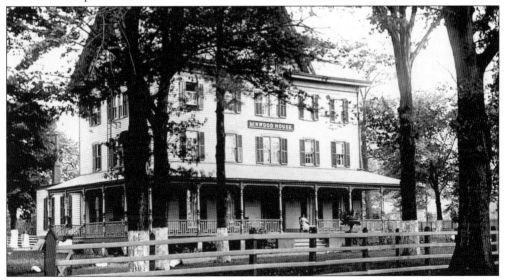

Linwood House, in Coytesville, was located on Linwood Avenue near Maple Street. It was built by Joseph Coyte during the Civil War. The water from a nearby "sulphur and iron spring" was bottled and sold in New York. The hotel, which sold no liquor, fell on hard times. John McKee refurbished it in 1907. It was torn down in 1938.

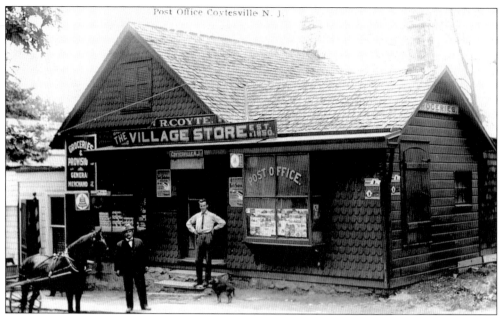

The Coyte store, established in 1850, was located on Washington Avenue near the trolley terminus. It housed the Coytesville post office. Joseph Coyte, the founder of Coytesville, was the first Coytesville postmaster. His son Reuben followed him in the position. In 1938, the post office moved to another building on Washington Avenue. It was closed on November 30, 1960.

Cy Prosch, a photographer and inventor of an automatic camera shutter and camera flash, lived on Short Street in Coytesville. Prosch was an advocate of prohibition and often complained about baseball games being played on Sunday. He was also a writer for New York and New Jersey newspapers. Prosch was one of the inspirations for the eccentric cast of characters drawn by George Price, the cartoonist of the *New Yorker*.

114

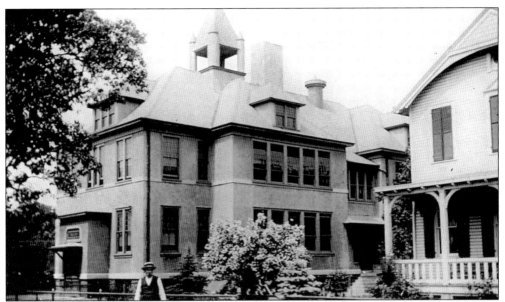

Coytesville's School No. 3 began as a one-room wooden schoolhouse on land sold to the school board by Joseph Coyte for $1. In 1889, it was expanded to four rooms, and in 1924, four more rooms were added. The school was closed from 1945 to 1951 because of hazardous conditions in the old building. The children were sent by bus to School No. 4 in Palisade.

Linwood Avenue was an early and important connecting road between Coytesville and Fort Lee's Main Street. The Academy of the Holy Angels and the Triangle and Peerless movie studios lined its southern portion. The northern end remained rural, except for the Linwood Hotel. In 1904, it was the scene of one of Fort Lee's greatest tragedies: the death of several Pagliughi children in a house fire.

Van Fleet Park, in Coytesville, is named for four-star general James Van Fleet, who was born there in 1892. The people of Coytesville never forgot Van Fleet, who graduated from West Point in 1915. His outstanding service to his country in three wars prompted the town to bestow this honor on their native son.

Members of the Ladies Auxiliary of Fire Company No. 2 are, from left to right, as follows: (first row) A. Faller, Mrs. George Walker (trustee), Mrs. E. Luderman (secretary), Mrs. J. Spina (president), Mrs. Ray Beyer (vice president), A. York (treasurer), Mrs. W. Keller (trustee), and Mrs. H. Lynch; (second row) E. Lang, Mrs. W. Faller, F. Barbanti, Mrs. J. Lang, Mrs. O. Satino, A. Bernard, Mrs. F. Walters, P. Carapetzi, and Mrs. F. O'Crane.

Seen in this 1943 photograph are, from left to right, Jackie Stengel, Muriel Murphy, Sookie Hart, Mildred Murphy, and Bobby Stengel—grandchildren of Charles and Selina Monaghan Hart. The children are seated on the steps of the Harts' Third Street home in Coytesville. Jackie and Bobby are the sons of Eleanor Hart Stengel; Muriel and Mildred, the twin daughters of Virginia Hart Murphy; and Sookie, the daughter of William S. Hart Sr.

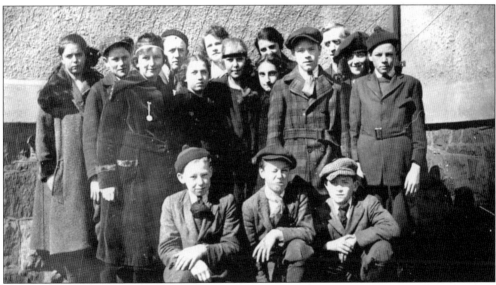

The 1919 graduating class of School No. 3 includes, from left to right, the following: (kneeling) George Low, Ted Bridges, and Pete Burns; (standing) Charlotte Mulligan, Lincoln Trueman, Mildred Kersting, Jim Murray, Eleanor Hart, Catherine Walker, Helen Rambo, Mamie Schmidt, Alice Gennett, Bill O'Rourke, Willard Waterbury (principal), Dorothea Ogelthorpe, and Ed McKenna. At the graduation exercises, Helen Rambo read "The Melting Pot," and Edward McKenna read "He Hath Put Down the Mighty from Their Sea."

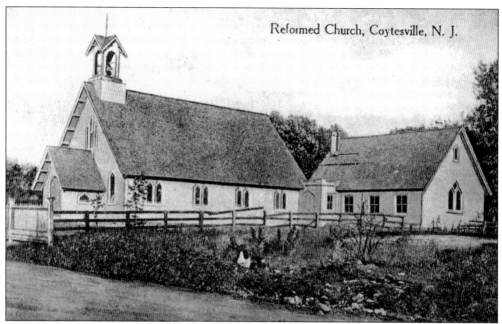

Reformed Church, Coytesville, N. J.

First Reformed Church of the Palisades is on Lemoine Avenue. Joseph Coyte donated two lots and sold a third to the Reformed Protestant Dutch Mission, which built the church in 1868. The Reverend Vermilye was the first pastor. The church was struck by lightning in 1890 and suffered a fire in 1896. *The Bergen County Historic Sites Survey 1980–1981* cites the design as an example of Gothic Revival and notes the building's stained-glass windows.

Catholic Church and Rectory
Coytesville, N. J.

The Holy Trinity church and rectory were dedicated in 1907. Catholics met in 1905 and agreed to petition the Newark Archdiocese to establish a parish. Their request was granted, and Rambo's Hall served as the temporary parish church. The first pastor was the Reverend Robert E. Freeman. The church has been renovated several times and the rectory replaced. The old rectory was moved to Fifth Street.

Barrymore House, on Hammett Avenue, was built before 1876. In 1900, Rose Moulton, an actress, purchased it. Moulton was the protégé of Maurice Barrymore, the father of John, Lionel, and Ethel Barrymore. Maurice Barrymore became very active in the community, even staging benefits for the fire company. Efforts to save the house as a historic site were thwarted, and it was demolished in 2002 to make way for multifamily homes.

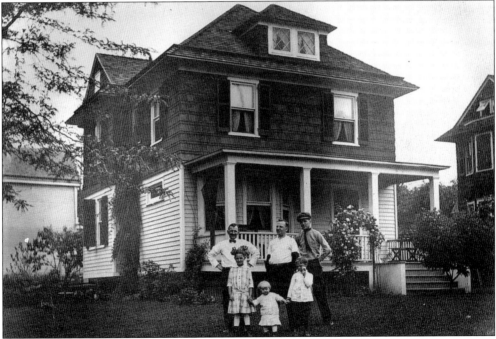

Gus Becker, wife Catherine, and their two children lived in this house on Myrtle Avenue. Becker worked at Rambo's Hotel as a bartender for many years before buying the tavern and former movie location in 1933. He ran the tavern until 1977, when he died. His home and the tavern (now a private home) have remained in his family.

The initial settlers often bought lots and later built their own modest homes, adding rooms as their families grew. William Dennis immigrated to the United States from Scotland in 1907. In 1922, he built this home at 437 Myrtle Avenue. He later added a dormer. In the early 1990s, the home was demolished and replaced with a two-family home.

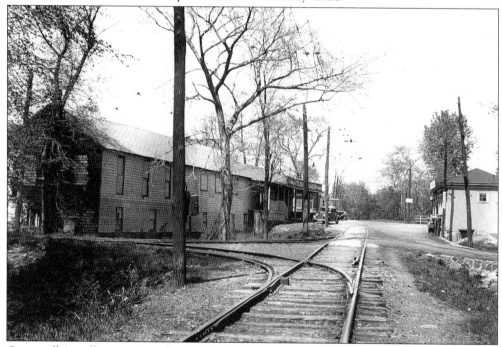

Coytesville's trolley terminated at Washington Avenue near Third Street. Devlin's El Rancho is on the left, and McFarland's ice-cream parlor is on the right. The Bergen line ran from the Edgewater ferry terminal to Abbott Boulevard and then north to Coytesville. It was discontinued in 1933. The route from Hudson County operated until 1938.

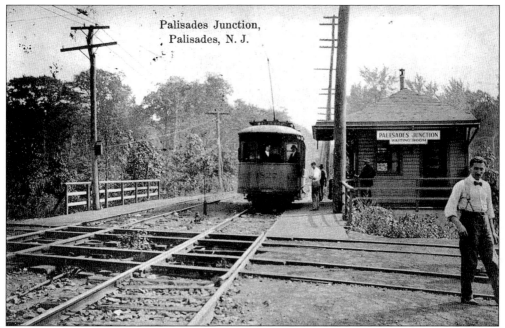

This postcard shows Palisade Junction *c.* 1907, just as Palisade, still independent of Fort Lee, was being developed. The small community had its "major" transportation facility in place in the 1890s, long before most of its homes were built. The trolley car shown originated its route in Hudson County. Coytesville was the end of the line.

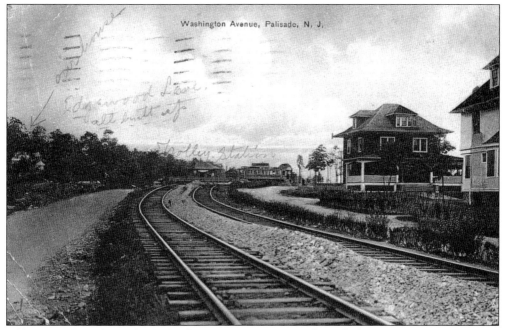

Abbott Boulevard, in the Palisade section, was originally called Washington Avenue. In August 1909, after Palisade was incorporated into the borough, the borough council changed the name to Abbott Boulevard to honor Fort Lee's first mayor, John C. Abbott. The change of name was necessary because there already was a Washington Avenue in Coytesville.

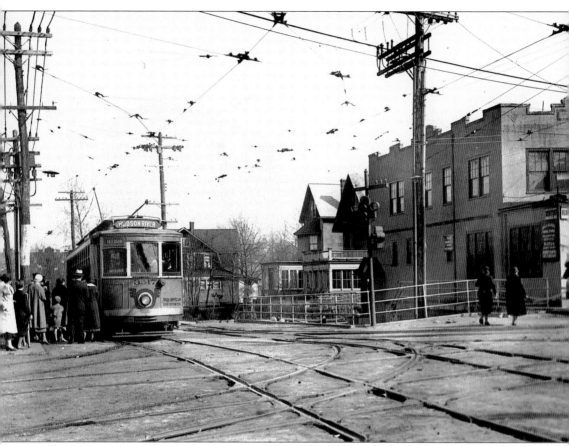

Fort Lee was one of the first communities to benefit from the laying of trolley lines in Bergen County. By the beginning of the 20th century, the Bergen Traction Company was operating lines through the town. In 1911, the Public Service Railway Company took over. One of its first actions was to try to force an extra fare on passengers who needed to transfer. It was particularly hard on laborers, who could ill afford the extra $2.50 per month. Some Coytesville riders would rather walk than pay the transfer fare. After much protest, the company acquiesced and rescinded the extra fare. Palisade Junction (above) was a major Bergen County trolley hub. Trolleys of the Hudson River line connected with Palisade line cars. Public Service owned both trolleys and, later, the buses that traveled the same routes. When the trolleys were discontinued, Public Service paved the roadbed at the junction to cover the trolley tracks. Bus lines had greater flexibility in changing routes.

Tarantino's (Jerry's) restaurant, established in 1922, was located at 1400 Palisade Avenue. It featured Italian American cuisine. For takeout, you could bring your own pot and have it filled, for example, with spaghetti and meatballs. In later years, it became the Horizon, Horizon East, and Harbor House. The building to the right was one of many tourist accommodations in Fort Lee. At one time, it was called the Lorelei.

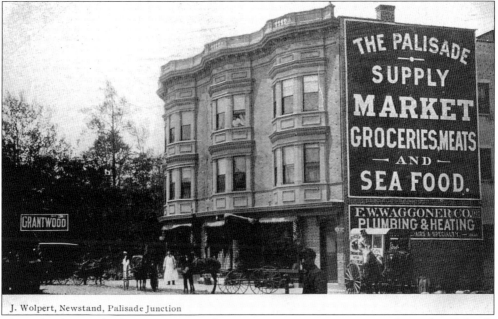

The Palisade Supply Company, soon after its construction c. 1910, was located at Palisade Avenue and Cumbermeade Road. The building still stands. It was one of the first commercial-multifamily apartment buildings in Palisade.

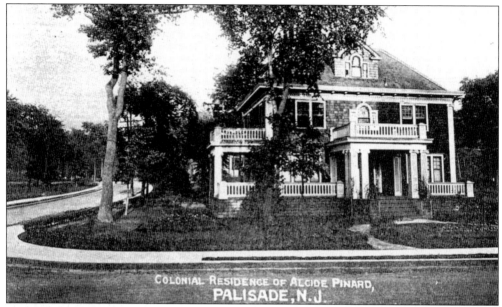

COLONIAL RESIDENCE OF ALCIDE PINARD,
PALISADE, N.J.

The Pinard House, at 1034 Cumbermeade Road, is listed in *The Bergen County Historic Sites Survey 1980–1981*. The large-frame Colonial Revival house was built between 1905 and 1911. Alcide and Evangeline Pinard owned the home from 1910 into the 1920s. Gustave Feuerbach and his wife purchased the home in 1925. Feuerbach was an importer of Chinese goods and, at one time, owned an extensive collection of Chinese art.

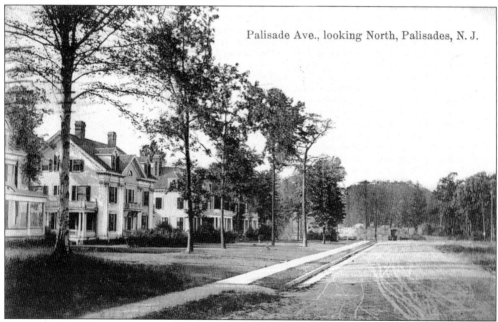

Palisade Ave., looking North, Palisades, N. J.

The three large Palisade Avenue homes seen in this c. 1912 photograph were built on lots developed by the Hudson River Realty Company between 1906 and 1910. All three still stand. Paul Brady, a Palisade pioneer, lived with his wife and 10 children at 1041 Palisade Avenue. His son Arthur served on the borough council; daughter Maud was a principal of School No. 4. The family owned the house into the 1960s.

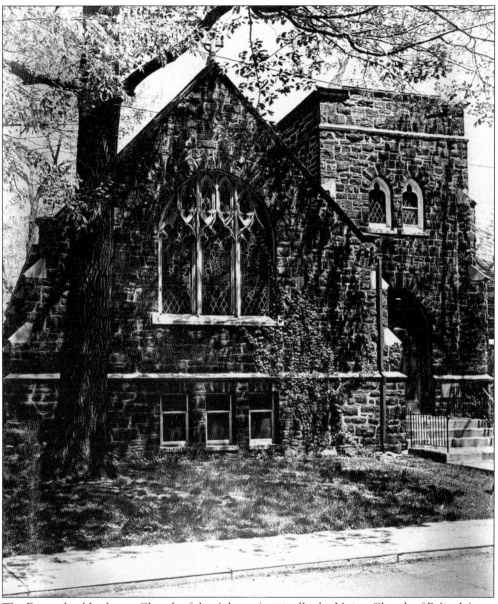

The Evangelical Lutheran Church of the Advent (originally the Union Church of Palisade) was built on Bridle Way in 1910. The property was donated by the Hudson River Realty Company with the condition the church remain nondenominational for 25 years. Its most controversial pastor was the Reverend Vincent Burns, who was locked out of the church after an altercation with a church official in 1936. The pastor then held services for those who were loyal to him in a log cabin located on his property on Buckingham Road. Burns also managed to get entangled in debates about the Lindbergh kidnapping. He was convinced that Hauptmann was innocent. Burns was the brother of Robert E. Burns, the man who wrote the book *I Am a Fugitive from a Chain Gang*. The church later elected to affiliate with a Lutheran congregation.

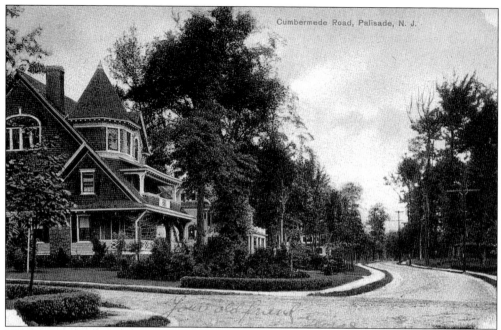

The Hudson River Realty Company built Dundee Gables on Cumbermeade Road *c.* 1907. It was originally the home of Charles T. Logan, the founder and editor of the *Palisadian*. The newspaper originated in 1906, when Logan's 14-year-old son declared he wished to become a journalist. In 1921, an irate female author threatened Charles T. Logan Sr. with a horsewhipping because of a negative review in the newspaper.

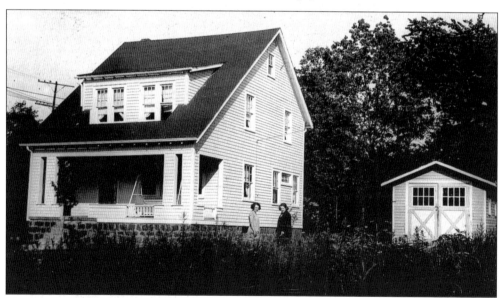

Mary and Emil Pellerano moved to this house at the corner of Columbia Avenue and Cumbermeade in June 1923. On a motorcycle trip from Manhattan in May of that year, the couple saw the home under construction and made a down payment. They bought the house for $11,000 from builder George B. Berghamp. Mary's brother Harry Barbagelata was among the graduates of Fort Lee's new high school in 1929.

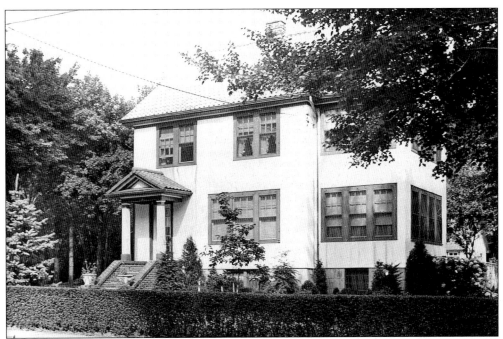

Joseph and Theresa Perona and their daughter Olga lived in this house at 1136 Cumbermeade for many years. Joseph Perona came to this country from Italy in 1905. He worked as a chef at El Morocco in Manhattan. Olga Perona married Jose Farre and continued to live in the house until she died in 1999. The Italianate-style home was torn down soon after her death.

Eleanor (left), Freda (center), and Alice (right) were the three daughters of Charles and Freda Ochsner. They lived on Cumbermeade Road in the 1920s. Charles Ochsner, born in Switzerland, came to the United States in 1907. He worked as manager of an embroidery factory.

The post office is adorned with murals painted by Work Projects Administration artist Henry Schnakenberg. The colorful artwork was completed in 1941 and was exhibited for a time at the Art Students League in Manhattan. This view depicts a family picnic on the Palisades.

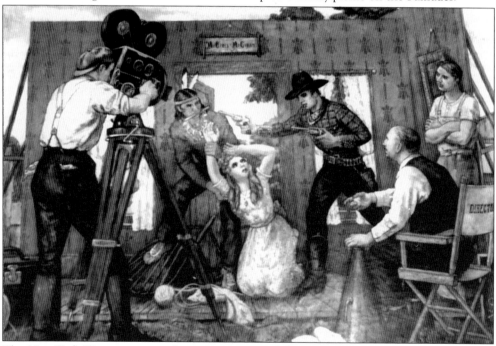

The *New York Times*, in a complimentary review of the works, described them as "vigorous" with a "disciplined power." Schnakenberg's four murals depict Henry Hudson discovering the Hudson River; George Washington on the Palisades; a picnic on the Palisades; and this interesting work on Fort Lee movie history.